POSTCARD HISTORY SERIES

Tyler

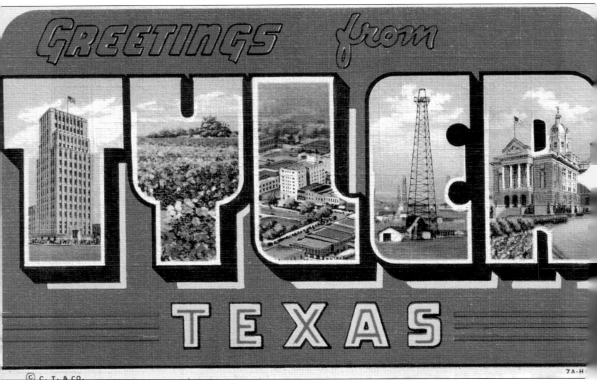

This postcard is of the large-letter, "greetings" type that was very popular with visitors of any city. These would include a different view within each letter of the city's name. Over the years, several versions were published for Tyler; this one is around 1937. The included views are, from left to right, Peoples National Bank, rose field, downtown aerial, oil field, and the county courthouse. (Author's collection.)

ON THE FRONT COVER: This late-1930s view is looking northeast across the traffic on North College Avenue. The county courthouse is seen in the center of the public square, with Citizens National Bank appearing in the background to the left. (Author's collection.)

ON THE BACK COVER: This *c.* 1906 postcard is looking northeast toward the buildings along Ferguson Street. Parked wagons cover the west side of the public square. With crowds lining the street, apparently a parade around the square is about to begin. (Author's collection.)

POSTCARD HISTORY SERIES

Tyler

Robert E. Reed Jr.

ARCADIA
PUBLISHING

Published by Arcadia Publishing
Charleston SC, Chicago IL, Portsmouth NH, San Francisco CA

Printed in the United States of America

Library of Congress Control Number: 2009925985

For all general information contact Arcadia Publishing at:
Telephone 843-853-2070
Fax 843-853-0044
E-mail sales@arcadiapublishing.com
For customer service and orders:
Toll-Free 1-888-313-2665

Visit us on the Internet at www.arcadiapublishing.com

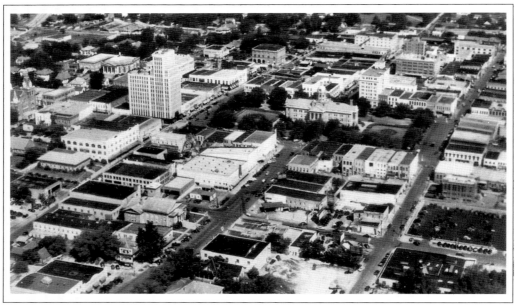

This postcard shows a downtown aerial view in the late 1940s. The stately county courthouse, completed in 1910, appears in the center of the public square. South Broadway Avenue directly approaches the courthouse from the lower left, and North Broadway Avenue continues on the other side of the square. After the 1955 demolition of this courthouse, the two sections of Broadway were joined for the first time. (Courtesy Smith County Historical Society.)

CONTENTS

ACKNOWLEDGMENTS

Every image in this book is from an actual postcard, with a majority coming from the author's personal collection. Additional postcards from other collections were used courtesy of the following organizations and individuals: Smith County Historical Society, Tyler Public Library, Mary Love Berryman, Calvin Clyde Jr., and Bill and Sue Corbin.

The sources utilized for caption information were issues of the Smith County Historical Society's *Chronicles of Smith County, Texas*, Dr. James Smallwood's two-volume *The History of Smith County: Born in Dixie*, vintage city directories and phone books, Sanborn insurance maps, U.S. Census records, and various other reference materials, both in print and online.

Special thanks go to Vicki Betts and Zelda Boucher, both of the Smith County Historical Society, for proofreading; the entire staff of Arcadia Publishing, from editor to sales manager, for support and encouragement; the Curt Teich Postcard Archives at Lake County Discovery Museum, Wauconda, Illinois, for assistance; my wife, Kay, for support and understanding; and my young son, Evan, for being Daddy's best publicity and sales manager!

I would like to dedicate this book to my mom, Virginia Reed, and my son, Evan. Virginia is the last living of the first generation of our Reed family to live in Tyler, while Evan is the third generation.

To learn more about the history of Tyler, contact:

Smith County Historical Society
125 South College Avenue
Tyler, Texas 75702
903-592-5993

For Tyler tourist information, contact:

Tyler Convention and Visitors Bureau
315 North Broadway Avenue
Tyler, Texas 75702
800-235-5712

INTRODUCTION

Postcards have always had a simple, modest purpose. They were a convenient way to let the folks back home know that you arrived at your destination safely or tell them what a great time you were having during your explorations out into the world. In early days, they also were an inexpensive way to augment travel memories during a time when the common family did not yet have their own camera. When they came in the mail, they would produce a smile or perhaps emptiness in the heart for a far-away sender. Afterward, if lucky, they were placed into a scrapbook or were tossed into a drawer.

As the years passed, so did many of the places and buildings on these postcards. In the days before historic preservation was even considered, we often let our past slip away to achieve the modern. Fortunately, historians and collectors came to realize that the common postcard transcended from its original purpose; they now were snapshots of history, and often they were the only remaining visual record of the places we lost.

This book presents well over 200 postcards from Tyler, Texas, covering the first seven decades of the 20th century. Obviously the book will not provide a comprehensive history of the city, for Tyler was here long before the postcard. Nevertheless, an interesting and important portion of Tyler's progress is covered, as well as the postcard's evolution from its golden age to the days of the photochrome. To give today's reader the best idea of a specific location, modern-day street names and numbers will be used or often a general street intersection description. Before we begin, a brief historic overview of postcard types is in order. While postcards originated back in the 1800s, we will focus on just the time period included in this book.

The undivided back era stretches from the end of 1901 through the start of 1907. The term undivided back refers to the fact that writing on the reverse side was restricted to the address of the recipient; the back was not "divided" to allow a message to be included there. During this era, a remarkable increase in postcard production was witnessed, with most of that done by European publishers. By the end of this period, deltiology, or postcard collecting, became the most popular hobby the world had ever seen.

The divided back era starts shortly into 1907 and continues to 1915 and is considered the golden age of postcards. A divided reverse on the postcard was now permitted, with the right side reserved for the recipient's address and the left side reserved for messages. While technically today's postcards are divided-backs, the range of the era is limited to this golden age. Millions of postcards were printed, mostly in Germany, and collecting reached new heights. The end of this era coincides with the start of World War I. The supply from Germany ended, and their quality was not matched by other publishers.

The white border era began in 1915 and lasts into 1930. In an effort to save ink, and hence save money, postcards had a white border around the view. The beautiful German lithography on earlier postcards was replaced by half-tone process printing by domestic publishers. The quality was not there anymore, so many American collectors lost interest, and the golden age came to an end.

The linen era is considered to be 1930 through 1945. Publishers began printing postcards with high rag content and bright dyes. The result was a quality improvement over white border postcards, with the product being cheaper to produce. This made a postcard a cheap way to advertise. While the era officially ended in 1945, linen postcards continued to be produced into the 1950s.

The photochrome era is considered to have started in 1939 when they first appeared, and continues to the present day. Also called chrome postcards, they were printed in a four-color, half-tone process with a varnish covering that created a high quality image, close to photographic quality, with great color.

Real-photo postcards do not belong to a particular era but need to be mentioned. This type of postcard is an actual photograph printed on backing that has a "postcard reverse side" printed on it, allowing it to be mailed. They actually started to appear before the 1900s and contain greater and clearer detail than any ink-based process could achieve. A real-photo postcard may have been volume-produced, or it could be one of a kind.

With the reader now more knowledgeable about the postcard aspect of this book, a little background about their subject, Tyler, might be helpful. Soon after Texas was admitted as a state, the Texas Legislature met in April 1846 and, among other business, created Smith County and decided its county seat would be named Tyler, honoring Pres. John Tyler for supporting the annexation of Texas. The same year, a spot for Tyler was located near the center of the county, on high ground with nearby springs. It was surveyed and lots were sold at auctions occurring through 1852. The first county courthouse was set up in an abandoned log cabin in 1846, and the next year brought the establishment of the first post office and the construction of the county's first jail. The Baptists and the Methodists each organized churches in 1848, and Masons organized a lodge by the end of that year. In 1850, the Texas Legislature incorporated Tyler, and a branch of the Texas Supreme Court was located there, which continued until 1892. In 1850, the population of Tyler was 276.

By 1860, the city's population reached 1,021. Tyler was now a stop on five stagecoach lines. During the Civil War years, Tyler was distanced from any actual fighting but nevertheless played an important role for the Confederacy. The Douglas Battery, with half of its men from Smith County and commanded by Tylerite James P. Douglas, was the only Texas artillery unit to serve east of the Mississippi River and reportedly the first Confederate unit to volunteer "for the duration of the war." Camp Ford, located 4 miles from Tyler, started as a training facility but eventually became the largest Confederate prisoner of war camp west of the Mississippi River. Among other wartime activities, Tyler produced rifles, ordnance, saddles, and medicines for the Confederacy. After the war, Reconstruction was a difficult time filled with political turmoil, but soon prosperity was upon the city.

In 1874, the International and Great Northern Railroad established a route through Tyler, and in 1877, the Tyler Tap Railroad was built, destined to become the oldest portion of the Cotton Belt Railroad. Railroad expansion meant more jobs and access to new markets for crops. Cotton growing became a profitable enterprise, with production increasing by five times between 1860 and 1880. Truck farming, especially fruit production, also increased dramatically, with shipments heading north. At the turn of the 19th century, Tyler was a promising, growing city.

Postcard memories will now carry Tyler's history into the 20th century.

One

STREET SCENES
AND BUILDINGS

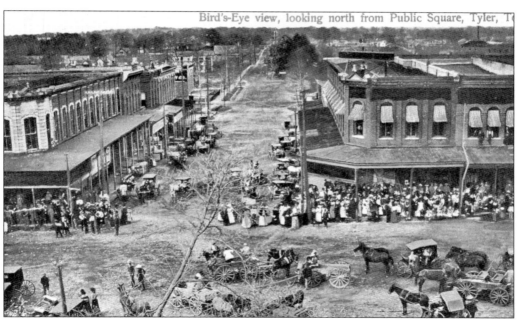

This *c.* 1904 view of North Broadway Avenue is from atop the 1851 courthouse. People line Ferguson Street in the foreground, perhaps awaiting a parade. The postcard manufacturer carefully blotted out all advertising signs, but the two-story building on the corner to the right housed the department store Olfenbuttel and Company. Citizens National Bank moved into this building in 1908. (Author's collection.)

9

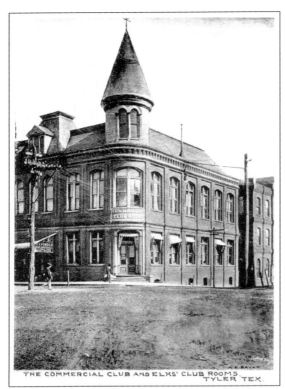

THE COMMERCIAL CLUB AND ELKS' CLUB ROOMS,
TYLER TEX.

Civic leaders founded the Tyler Commercial Club on June 2, 1900. Located on the southeast corner of South Spring Avenue and East Erwin Street in the Durst and Bergfeld Building, constructed in the early 1890s, it was the forerunner of the Tyler Area Chamber of Commerce and the Tyler Economic Development Council. This building also housed the Elk's Club on the second floor. On the far right of this postcard, the Grand Opera House is partially visible. A devastating fire struck this corner on April 6, 1907. The postcard below, with the exact same view, shows the empty shell that remained of the building after the fire. (Left, author's collection; below, courtesy Smith County Historical Society.)

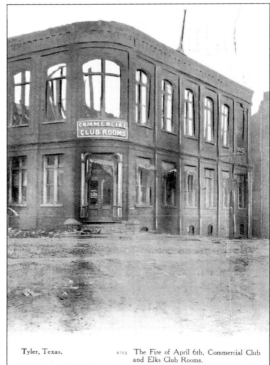

Tyler, Texas. 4765 The Fire of April 6th, Commercial Club and Elks Club Rooms.

This view along the east side of South Spring Avenue is of the destruction caused by the fire of April 6, 1907. In the foreground are the remains of the Grand Opera House, built in 1889, while the Tyler Commercial Club remains are in the left background. An earlier Grand Opera House was built on this same spot in November 1888. It, too, was destroyed by fire, only one month after opening. (Author's collection.)

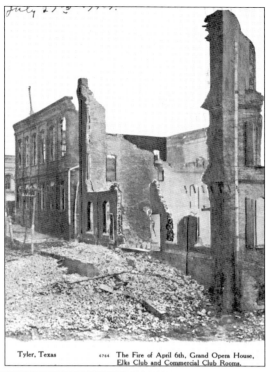

Tyler, Texas 4764 The Fire of April 6th, Grand Opera House, Elks Club and Commercial Club Rooms.

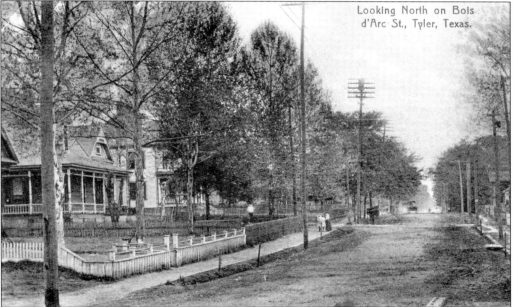

Looking North on Bois d'Arc St., Tyler, Texas.

This *c.* 1907 view is along the 400 block of North Bois D'Arc Avenue, looking north from the St. Louis and Southwestern Railway track crossing. Just a couple of houses up the street is the intersection with West Common Street, today called West Oakwood Street. A couple of blocks farther would be the Goodman-LeGrand House on the right and, just beyond on the left, Marsh School. (Author's collection.)

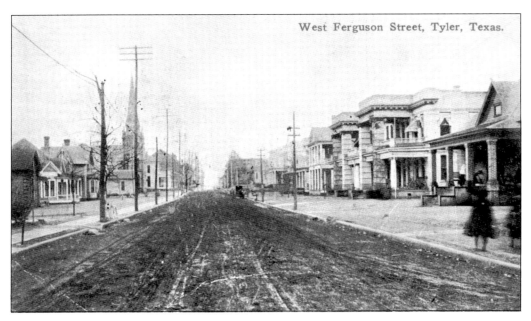

The above *c.* 1905 view is looking east along West Ferguson Street, about three blocks west of the square. The second building from the right is the Baldwin Flats, while farther down on the left side of the unpaved street is the steeple of First Presbyterian Church. The below view is looking west along the 100-block of East Ferguson Street. The light-colored, three-story building, fourth from the right, is the Yarbrough Building, built around 1859. Visible farther down the street is Swann Furniture Company, near the center of the postcard, on the northwest corner of the intersection with North Broadway Avenue. The public square appears to the left, and in the distance, the steeple of First Presbyterian Church is visible again. (Both, courtesy Bill and Sue Corbin.)

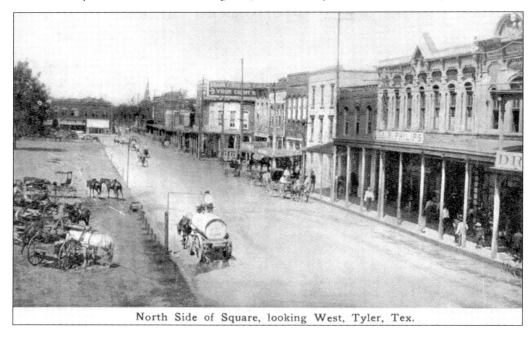

North Side of Square, looking West, Tyler, Tex.

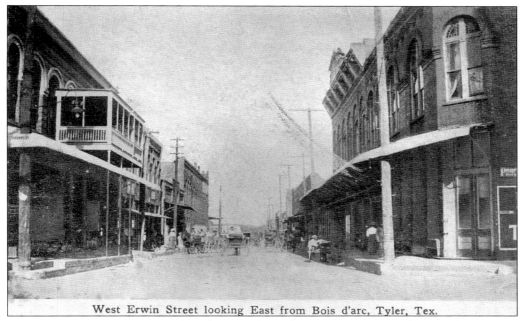

West Erwin Street looking East from Bois d'arc, Tyler, Tex.

The *c.* 1907 view is looking east along the 200-block of West Erwin Street, with Bois D'Arc Avenue crossing in the foreground. Marvin Methodist Church originally stood on the corner to the right from 1852 to 1889. The public square is just a block ahead to the left. During this time, this block was lined with such shops as grocery stores, butchers, and barbers. (Author's collection.)

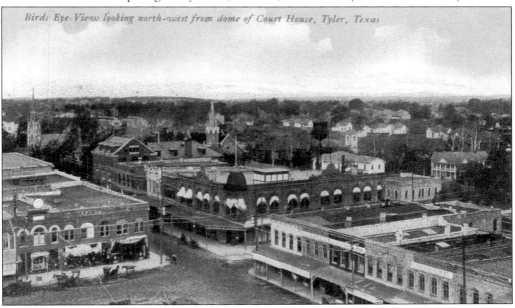

Birds Eye View looking north-west from dome of Court House, Tyler, Texas

This *c.* 1910 postcard is from a series of eight taken from atop the courthouse. This northwest view is of the intersection of North College Avenue, entering from the lower left, and West Ferguson Street. The Mayer and Schmidt department store appears on the corner in the center. The church steeples in the background are, from left to right, First Presbyterian Church, First Baptist Church, and Christ Episcopal Church. (Courtesy Bill and Sue Corbin.)

13

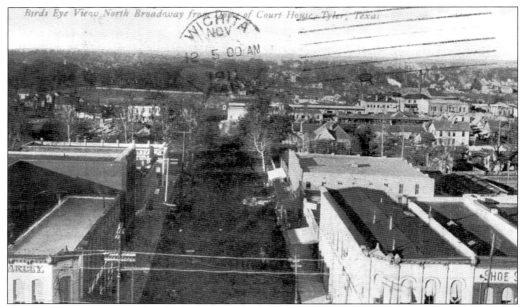

These *c.* 1910 postcards are from the series of eight taken from atop the courthouse. The north view above shows North Broadway Avenue, with Ferguson Street just out of view across the bottom. In the left foreground is the Starley Drug Company, while the original Citizens National Bank building is to the right. North Broadway Avenue narrows a few blocks in the distance at the Carlton Lumber Company. The northeast view below includes the shadow of the courthouse dome, with smoke visible in the distance from the Cotton Belt rail yards. The businesses along East Ferguson Street appear along the bottom, including the Yarbrough Building, fourth from the left, which was Tyler's first three-story building and a cartridge factory during the Civil War. The building was demolished in 1978. (Both, author's collection.)

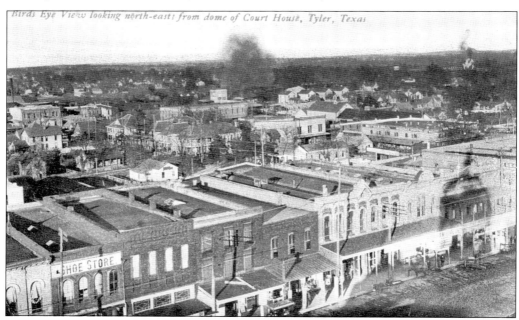

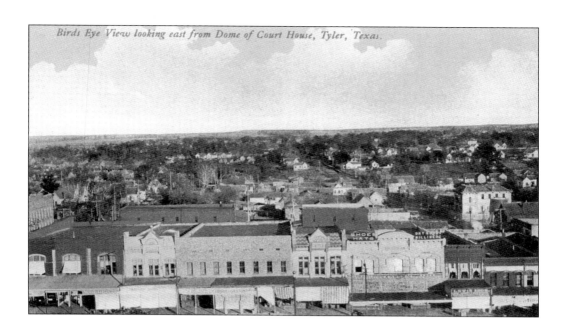

Birds Eye View looking east from Dome of Court House, Tyler, Texas.

These *c.* 1910 postcards are from the same series taken from atop the courthouse. The eastward view above shows the businesses along North Spring Avenue, many of which have sun screens hanging along the covered sidewalk to block the afternoon sun. Third from the right is Lipstate's, once a popular department store. The southeastward view below shows the intersection of Spring Avenue with East Erwin Street. Behind the two-story building on the opposite corner is the old wagon yard, where visitors to town could park their wagons and stable their horses. Farther beyond, a train can be seen on the International and Great Northern Railroad track. (Both, author's collection.)

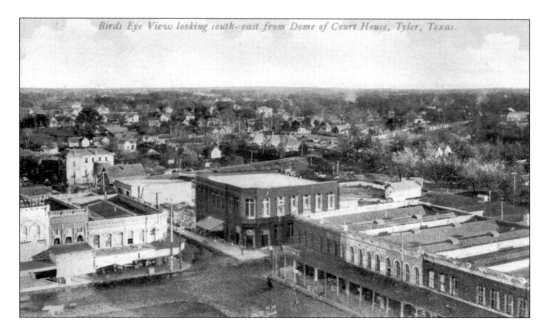

Birds Eye View looking south-east from Dome of Court House, Tyler, Texas.

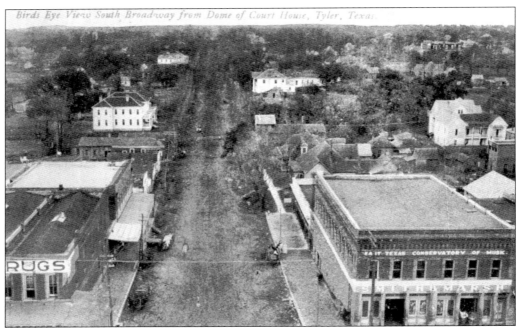

These *c.* 1910 postcards are from the same postcard series. The southward view above is of South Broadway Avenue, with Erwin Street just out of view across the bottom. In the left foreground is Clark's Drug Store, while the building to the right housed on the first floor the mercantile store Smith and Marsh and on the second floor the East Texas Conservatory of Music. This music school was started in 1902 by pianist Juan Roure from Barcelona, Spain, and popular soprano Estelle Burns from Tyler. The school closed in 1910. The southwest view below shows the businesses along West Erwin Street, with College Avenue intersecting to the right. On College Avenue, beyond the large white building, the original Tyler Commercial College building can be seen, with Carnegie Library to the left of it. (Both, author's collection.)

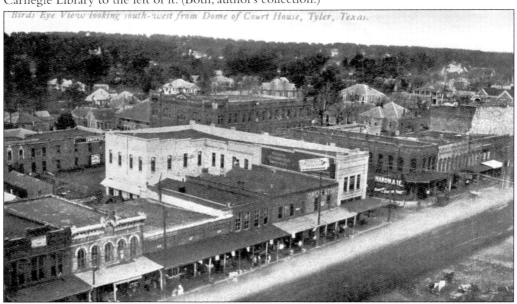
Birds Eye View looking south-west from Dome of Court House, Tyler, Texas.

16

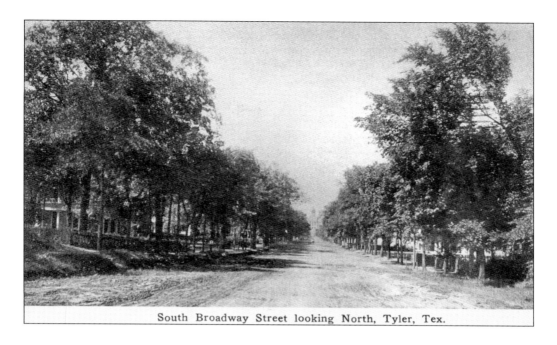

South Broadway Street looking North, Tyler, Tex.

These postcards both show the same general section of South Broadway Avenue, somewhere south of Front Street in the early 1910s, but from opposite directions. The top view is looking north, with residences visible along both tree-lined sides of the unpaved street and the courthouse appearing straight ahead in the distance. The bottom view is looking south, through more residences trailing off into the distance. When Broadway Avenue was eventually paved, for a long time it only went as far south as Rose Hill Cemetery, where it veered to the east and became the Troup Highway. (Both, author's collection.)

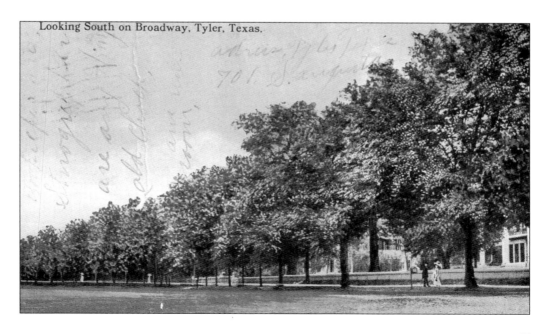

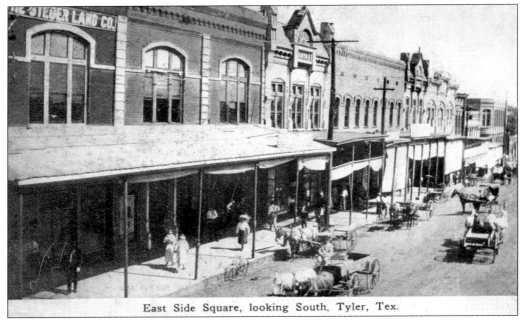

East Side Square, looking South, Tyler, Tex.

These postcards both show the same section of North Spring Avenue but from opposite directions and different times. The top view is in the early 1910s looking south from the intersection with East Ferguson Street. The only readable sign is for the Steger Land Company to the far left, but the Queen Theater is in the adjoining building to the right. Tyler's first Brookshire's store opened in 1928 around mid-block. The bottom view is from the late 1930s looking north, with East Erwin Street crossing in the immediate foreground. Visible signs include Wheeler's, K. Wolens Department Store, Devenport, Buck's, The Toggery, Sol Edelman, Arcadia Theater, Hix Drugs, Hotel Mac, and Lou's Hat Shop. Along Spring Avenue, a couple of blocks farther north, were boardinghouses, two of which were closed in 1936 as "bawdy houses." (Above, author's collection; below, courtesy Mary Love Berryman.)

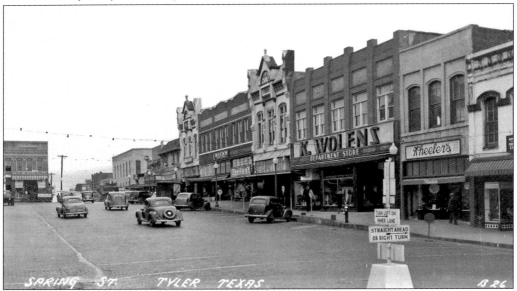

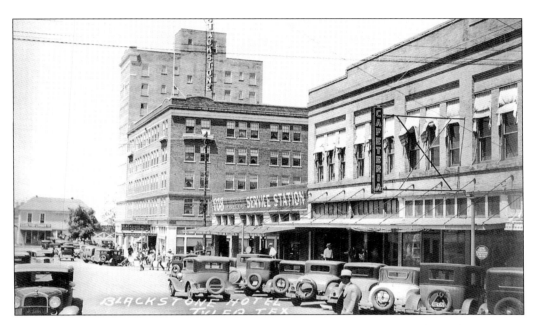

These postcards are both from the mid–1930s and show the same section of North Broadway Avenue from opposite directions. The above view is looking north, showing the east side of Broadway, including Cameron Cafeteria, Tyler Hardware Company, Six-O-Eight Service Station, and the Blackstone Hotel just after the Locust Street intersection. Beyond, Carlton Lumber Company is visible. Broadway narrowed to the left of the lumberyard at the East Line Street intersection. The view below is looking south, with signs visible for the Union Bus Station, Postal Telegraph Company, the Blackstone Pharmacy, the Blackstone Hotel, and Starley-Clark Drugs. The Citizens National Bank Building is seen in the left background at the intersection with Ferguson Street, which crosses in front of the courthouse's north side. (Both, author's collection.)

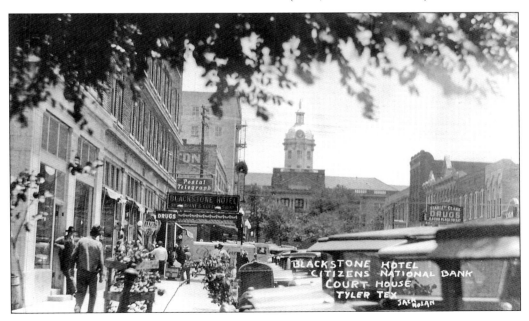

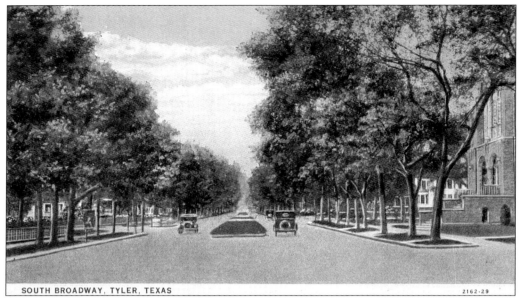

SOUTH BROADWAY, TYLER, TEXAS 2162-29

These postcards both show the intersection of South Broadway Avenue and Front Street but from opposite directions and at different times. The above view is from the early 1930s looking south, with Front Street crossing just beyond the automobiles, which are driving on a divided Broadway. University Place dead ends into Broadway at the far right, with First Christian Church on the corner. The 1940s view below is looking north. Immaculate Conception Catholic Church, which was built in 1934 on the land just north of the Bell residence, appears to the left. A Brookshire's Food Store, reportedly the first air-conditioned grocery store in East Texas, is on the northwest corner of the West Front Street intersection, with First Christian Church just beyond. (Both, author's collection.)

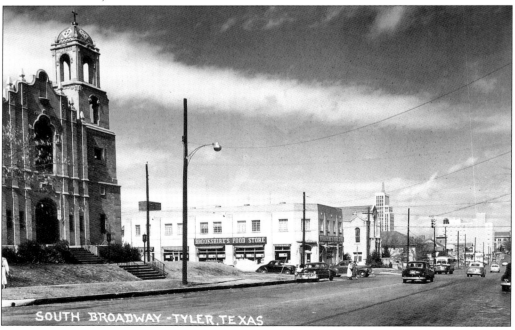

SOUTH BROADWAY - TYLER, TEXAS

Both of these postcards show the same view, looking west along East Erwin Street with Spring Avenue crossing in the foreground, but are from different decades. The view at right, late 1930s, includes beer signs for Southern Select, Falstaff, and Schlitz. After the 1933 repeal of the nation's Prohibition Amendment, 3.2-percent beer and wine sales were legal in Tyler through the end of 1939. The below view shows the back and south sides of the current courthouse, completed in 1955, with Broadway Avenue passing in front of it. Christmas decorations can be seen hanging from the poles, with a large artificial tree on the public square, visible just beyond and to the left of the courthouse. A sign for the long-gone Majestic Theater is seen to the left. (Both, author's collection.)

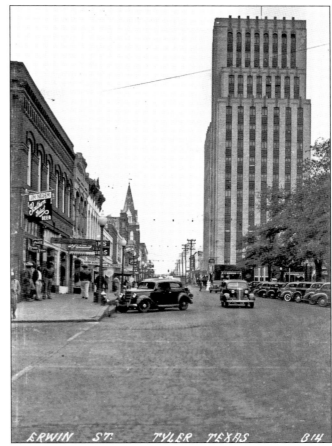

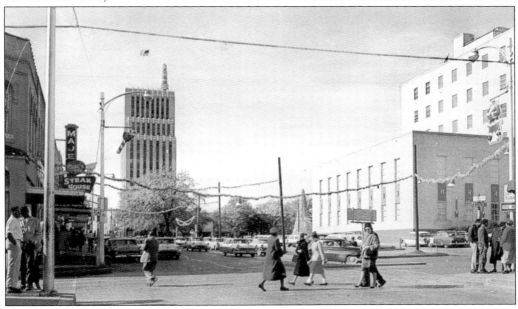

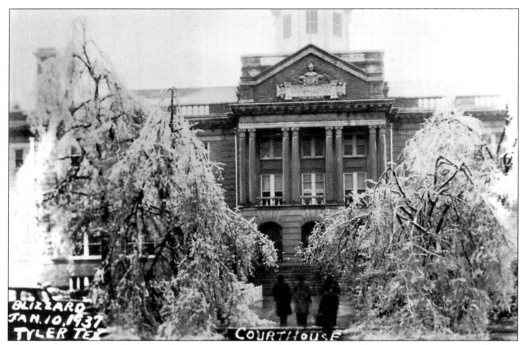

Allen Nicks, a local photographer, took a series of photographs of a January 10, 1937, blizzard that he made into postcards; two are shown here. More an ice storm than a blizzard, it caused widespread damage with fallen tree limbs, downed power lines, and lampposts knocked over. Locals recalled how it was the only time that all the movie theaters in town were closed at the same time. The view above is of the county courthouse, while the one below looks across the west side of the public square at Peoples National Bank. (Above, author's collection; below, courtesy Tyler Public Library.)

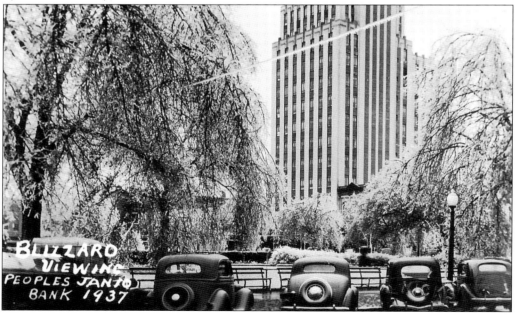

Two

Courthouses and the Public Square

WEST VIEW SMITH COUNTY COURT HOUSE, TYLER, TEX.

After a series of three log cabins over five years served as the county courthouse, the cornerstone was laid in December 1851 for a new courthouse, Tyler's first brick structure. The two-story building was 40 feet by 70 feet and sat in the middle of the square. In 1876, a third story was added, as well as a clock tower that never had a timepiece installed. (Courtesy Smith County Historical Society.)

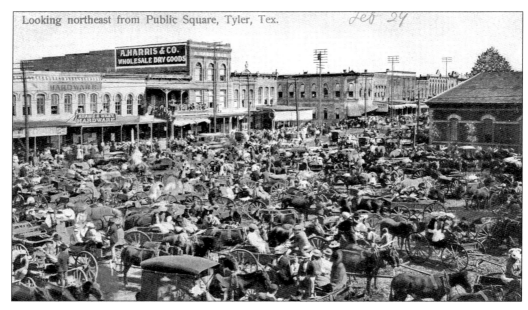

Both of these *c.* 1906 postcards are looking northeast across a portion of the public square. Five brick buildings were located on the square: the main courthouse in the middle with four other government offices in each corner. The building visible to the far right in both of these views is the district clerk's office, built in 1855 in the northwest corner of the square. Each leg of this L-shaped structure measured 50 feet by 25 feet. The above view shows a very crowded square, with people lining West Ferguson Street, most likely awaiting a parade. Visible businesses are E. G. Connally, Adams and Wiley Hardware, and A. Harris and Company. The view below shows a less busy day, and the name of the hardware store now appears as J. H. Adams and Son. (Both, author's collection.)

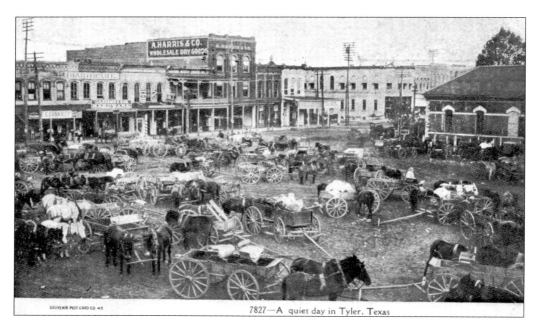

7827—A quiet day in Tyler, Texas

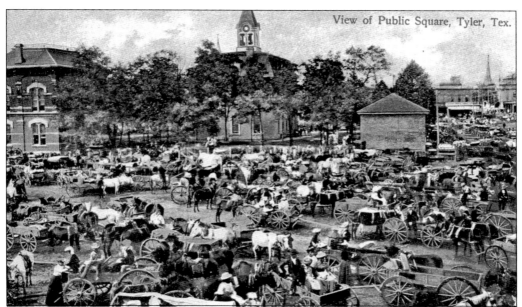

View of Public Square, Tyler, Tex.

This *c.* 1905 view looks west across the east side of the public square. The 1851 courthouse appears in the middle, with the two-story Court of Appeals building to the left, built in 1884 with dimensions of 35 feet by 50 feet. To the right is the one-story county clerk's office, a two-room building completed in 1858. Large areas for wagons were on the east and west sides of the square. (Author's collection.)

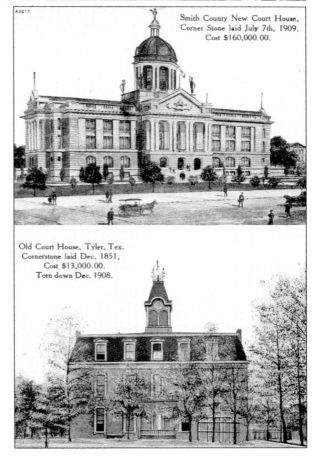

Smith County New Court House, Corner Stone laid July 7th, 1909. Cost $160,000.00.

Old Court House, Tyler, Tex. Cornerstone laid Dec. 1851, Cost $13,000.00. Torn down Dec. 1908.

By the early 1900s, the 1851 courthouse was outgrown. Demolition of it and the square's other four buildings began in December 1908. Reportedly the bricks, made just east of Oakwood Cemetery almost 60 years earlier, were salvaged for reuse in the new courthouse. The new building would also sit in the center of the square, and its cornerstone was laid in July 1909. This postcard shows both the old and new courthouses. (Author's collection.)

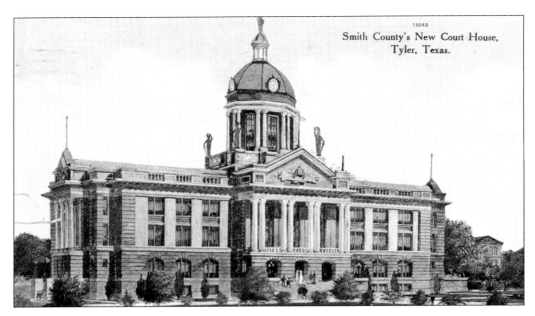

The above postcard was postmarked months before the cornerstone was even laid for the new courthouse. Two obvious inaccuracies in this drawing are the placement of statues around the base of the dome and the double columns supporting the dome itself. The dome, 36 feet in diameter, was topped by an 11-foot copper statue of Themis. This statue of the Greek goddess of law and justice faced north, as seen in the north-side view of the courthouse below. During the Christmas season, the statue held a lighted five-point star, and strings of lights would hang from the dome, draped across the streets in all directions to the tops of businesses around the square. When this courthouse was eventually demolished, the statue was saved and can now be seen in the Smith County Historical Society's museum. (Both, author's collection.)

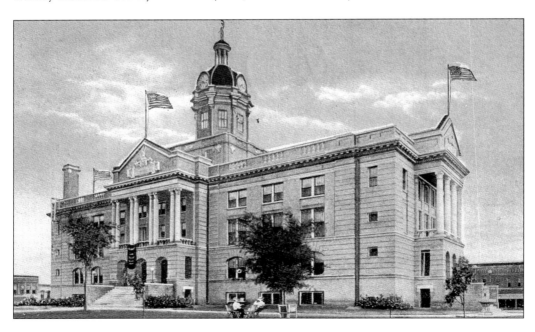

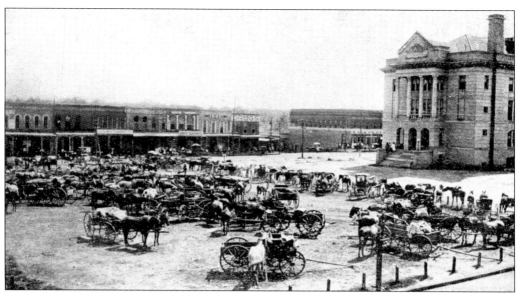

The above view from the early 1910s looks southwest across the east side of the public square, probably taken from a building located at the intersection of North Spring Avenue and East Ferguson Street. The square still lacks landscaping since the completion of this courthouse. Visible signs along Erwin Street on the far side of the square include David Korkmas and Smith and Marsh. The below view from decades later looks in the same direction but focuses on the courthouse. Both views show the chimney that rose from the northeast corner of the building. The 165-foot-tall courthouse was dedicated in October 1910, comprised of three stories and a basement level. A columned portico marked the entrances on each of the four sides, and each portico had a different pediment design. (Both, author's collection.)

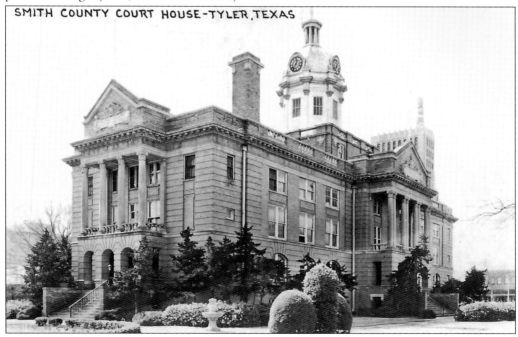

SMITH COUNTY COURT HOUSE-TYLER, TEXAS

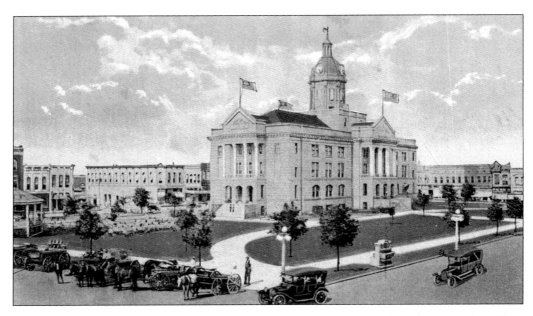

The above view is looking northeast, showing horse-drawn wagons parked along North College Avenue side of the public square. The automobiles are driving on West Erwin Street, with a curbside marble watering trough seen between them. Another trough was on the opposite side of the public square. Visible on the square to the far left is a bandstand, where the Tyler Municipal Band performed weekly concerts for many years. The original two-story Citizens National Bank building appears in the background, just to the left of the courthouse. The below view is looking northwest across East Erwin Street and is obviously from a later date. The new eight-story Citizens National Bank building, completed in 1924, is visible in the background to the right of the courthouse, and the trees on the square have grown considerably. (Both, author's collection.)

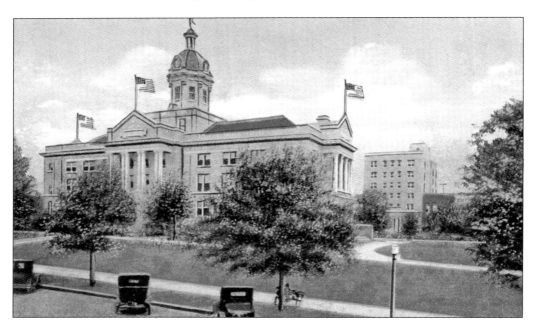

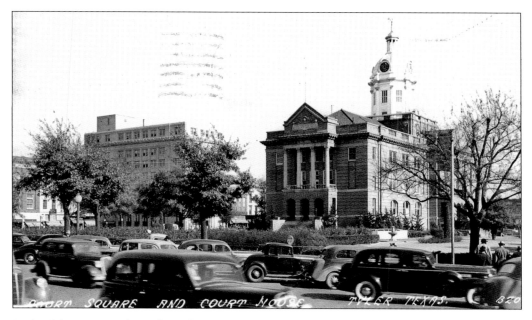

Both of these postcards are from the late 1930s. The above view is looking northeast across North College Avenue. In the background, businesses are visible along Ferguson Street, with the most prominent being the eight-story Citizens National Bank building. The below view is of the north face of the courthouse, which borders Ferguson Street. Beyond the trees on the west side of public square, Peoples National Bank can be seen, the tallest building at that time. The above view was most likely taken from in front of this bank building. Also in the view below, the courthouse's cornerstone is visible in the far right column at the top of the entrance stairs. In just a couple of decades, Broadway Avenue would replace this courthouse at the square's center. (Both, author's collection.)

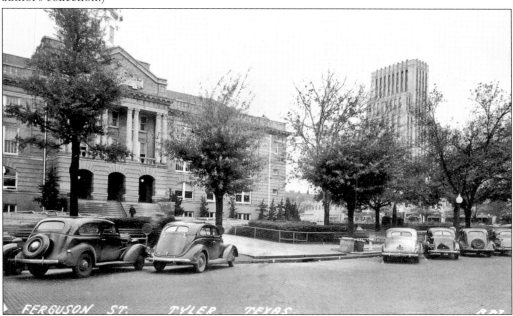

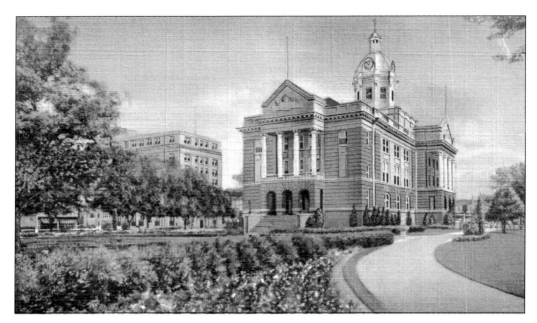

Both of these views look northeast and show the beautiful landscaping surrounding the courthouse in its later years. The below aerial view, taken from atop the Peoples National Bank, gives a great view of the entire public square. Also visible is Citizens National Bank rising to the left of the courthouse, and beyond it can be seen the Cotton Belt rail yards. Over the years, the public square has served as the location for the first East Texas State Fairs, weekly band concerts directed by John "Doc" Franklin Witt, and countless domino games. Many parades have also circled the square, including one in 1919 to welcome home World War I veterans, as well as the earliest Rose Parades. The annual Christmas parade still does so today, and the children anxiously wait to see Santa at the end. (Both, author's collection.)

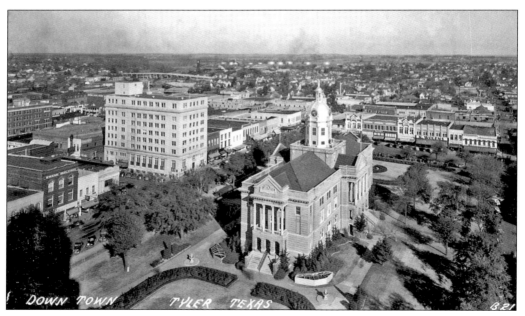

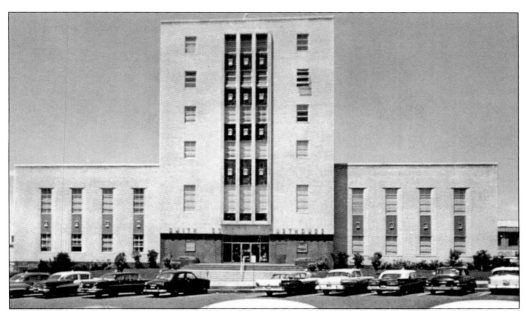

Construction on a new courthouse began on February 23, 1954, immediately east of the existing courthouse, on the land making up the east side of the public square. The six-story building, which also has a basement, cost approximately $1.5 million, and it was dedicated on August 1, 1955. The top two floors housed the county jail, later relocated to a separate facility. Demolition of the previous courthouse building began on September 29, 1955, and once completed, the front side of the new courthouse, facing west, was finally fully exposed, for it was obscured during construction by the close proximity of the previous courthouse. With the prior courthouse, which sat in the middle of the public square, now gone, the north and south sections of Broadway Avenue were connected for the first time in Tyler's history. (Both, author's collection.)

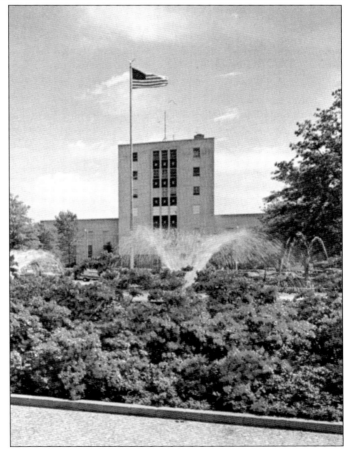

When the two sections of Broadway Avenue were joined after the prior courthouse's demolition, the west portion of the original public square stood alone, no longer adjoining the courthouse for the first time. During a January 27, 1966, ceremony that included Texas governor John Connally as a speaker, the land was dedicated as T. B. Butler Fountain Plaza. The renovations included a 70-by-20-foot "dancing waters" fountain, illuminated at night. The plaza remains a part of many activities, including many years in the past when a small house stood there for children to visit with Santa during the Christmas season. The plaza is also the location of a grave. A friend of many downtown regulars, Shorty the Squirrel died in 1963, and his tombstone can still be found in the southeast corner of the plaza. (Both, author's collection.)

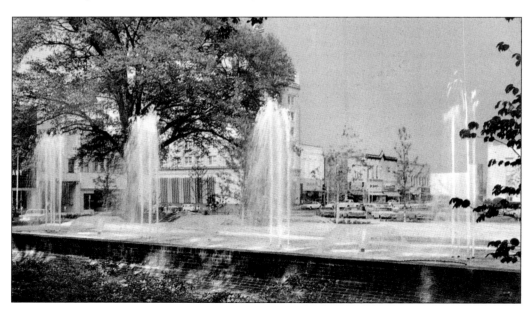

Three

PUBLIC BUILDINGS

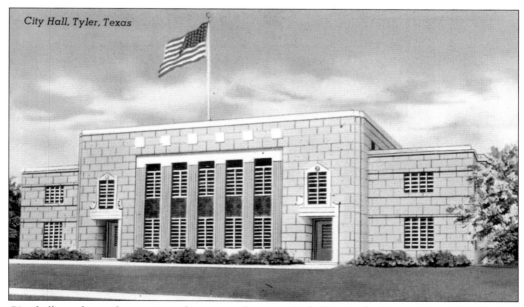

City Hall, Tyler, Texas

City hall was located at various places over the years, including in the Locust Street Fire Station. It was in the old Dr. Aaron Baldwin house just before the current location at 212 North Bonner Avenue, shown above. The building, costing $125,000, was made possible by the Public Works Administration, a New Deal program, and dedicated on August 3, 1939. (Author's collection.)

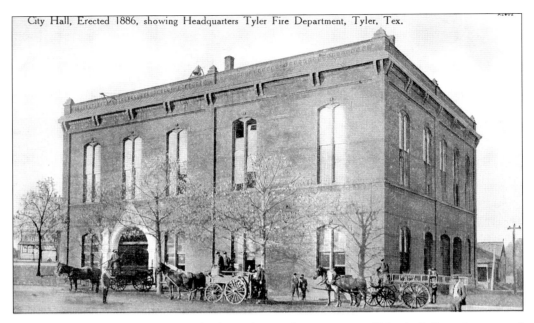

City Hall, Erected 1886, showing Headquarters Tyler Fire Department, Tyler, Tex.

The Locust Street Fire Station was built on the northwest corner of North College Avenue and West Locust Street in 1886. Over the years, the structure at times concurrently served other purposes, such as the police department and city hall. These postcards include views of the early horse-drawn fire department. Visible atop the building in the above postcard is a bell used to summon the firefighters when they were not at the station. The bell was originally used on the first building that housed Marvin Methodist Church from 1852 to 1889. After the church moved and no longer had a belfry, they loaned the bell to the fire department. When this building was demolished in 1955, the bell was returned to the church, and it is currently displayed on their east lawn along South Bois D'Arc Avenue. (Both, author's collection.)

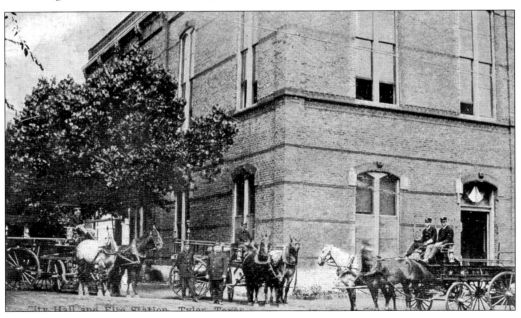

City Hall and Fire Station, Tyler, Texas

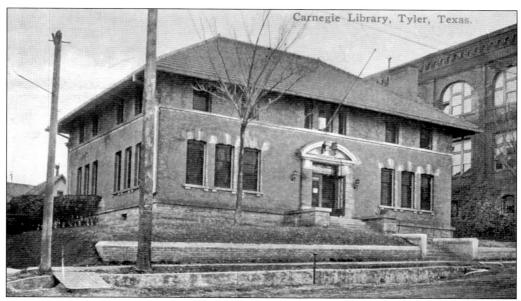

Carnegie Public Library, located at 125 South College Avenue, opened October 3, 1904. It was constructed with a $15,000 donation from philanthropist Andrew Carnegie, while private funds paid for the lot and furnishings. With two large rooms on the first floor and an auditorium called Carnegie Hall on the second, the library was designed to hold 12,000 books and be operated by one librarian, paid $35 monthly. An expansion in 1936 doubled its size, courtesy of a Public Works Administration grant. Library service for African Americans was segregated until the 1960s. A new public library opened at 201 South College Avenue on May 5, 1980. The old library, one of a dwindling number of original Carnegie Library buildings still standing in Texas, now serves as the museum and archives of the Smith County Historical Society. (Both, author's collection.)

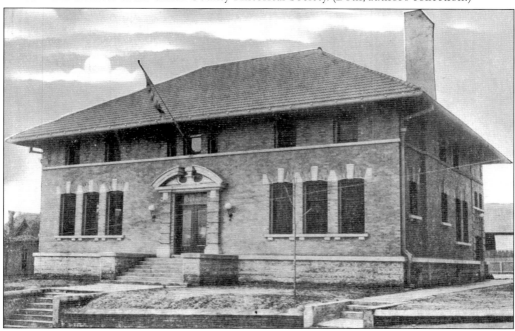

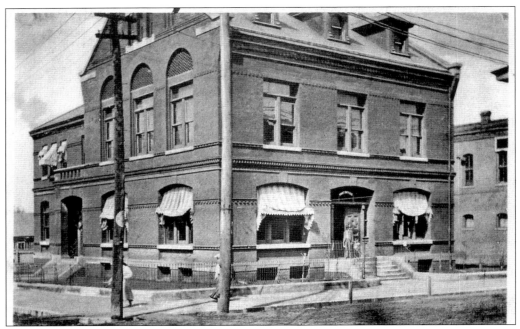

The first post office in Tyler opened on the southeast corner of South College Avenue and West Erwin Street in March 1847. Over the following decades, the post office would relocate 11 times before moving into the new Federal Building, shown above, in 1886. Located on the northeast corner of North Bois D'Arc Avenue and West Ferguson Street, the structure housed the post office on the ground level and a federal court and offices on the second floor. Space needs required a two-story northward extension of about 50 feet in 1908, visible below in the left background. During this construction, the front door was also moved from the center to the left. (Above, courtesy Smith County Historical Society; below, author's collection.)

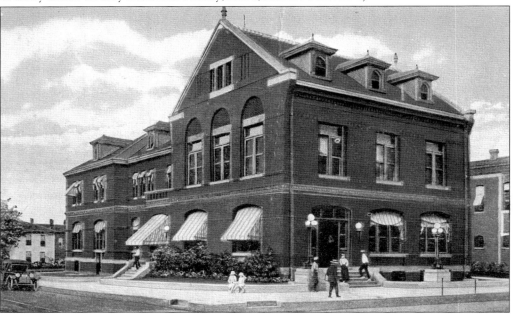

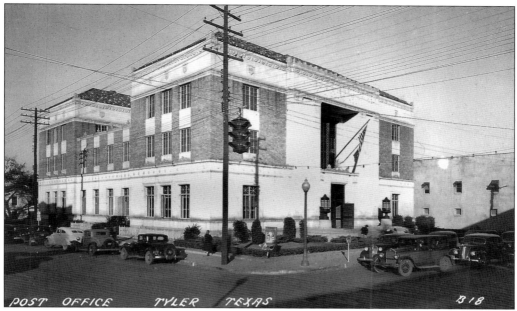

The 1886 Federal Building was demolished in 1933 to make way for the new U.S. Post Office and Courthouse, shown above. Much of the old structure's lumber and bricks were reused in new residences. The new building, dedicated in August 1934, cost $350,000 and was designed by local architect Shirley Simons. The post office moved to a new location in 1981, leaving this building for only federal court use. (Author's collection.)

Tyler Municipal Airport opened in 1930 on Highway 31, west of the city. In 1934, the airport was renamed Rhodes Field after Russell Rhodes of the chamber of commerce. During World War II, the city leased it for use as an army airfield. During this time, the airport was renamed Pounds Field to honor Tylerite 2nd Lt. Jack W. Pounds, killed in a 1942 plane crash. (Author's collection.)

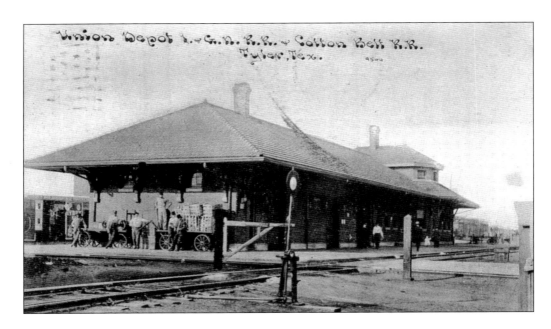

Located at 210 East Oakwood Street, the Cotton Belt passenger depot opened in 1905. The International and Great Northern Railroad track passed along the building's east side, and for a time, the depot also served their passengers. The last passenger train departed Tyler in April 1956, and the depot was used for various purposes after that. In 1988, it was donated to the City of Tyler, and in 2003, after extensive restoration, it became the home of Tyler Transit, occupying the old passenger waiting rooms, with the Cotton Belt Rail Historical Society staffing a museum in the former baggage storage area. The above postcard shows baggage carts along the depot's east side, while the view below includes a glimpse in the background of the St. Louis and Southwestern Railway warehouse that lined the track to the east. (Both, author's collection.)

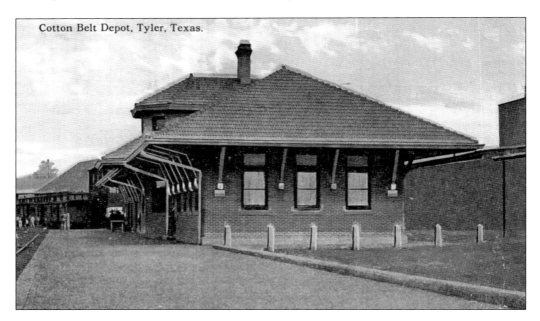

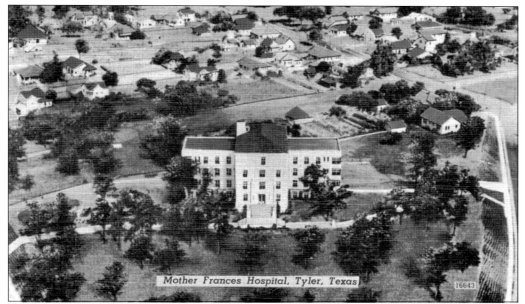

Mother Frances Hospital, Tyler, Texas

16643

After a local 1930s movement to fund an adequate medical facility failed, Tyler was fortunate to become the first city to receive a Public Works Administration grant for a hospital. Many sites were considered before the location at 800 East Dawson Street was selected, including land now part of the University of Texas at Tyler campus and property north of town owned by the Ku Klux Klan. The Sisters of the Holy Family of Nazareth won the contract to manage the hospital, and it opened on March 19, 1937, a day early to accept injured from the New London school explosion. Mother Frances Hospital, named in honor of Frances Siedliska, was later purchased by the Sisters. Above is an aerial view of the original building, while below is a four-story wing dedicated in 1948. (Above, author's collection; below, courtesy Smith County Historical Society.)

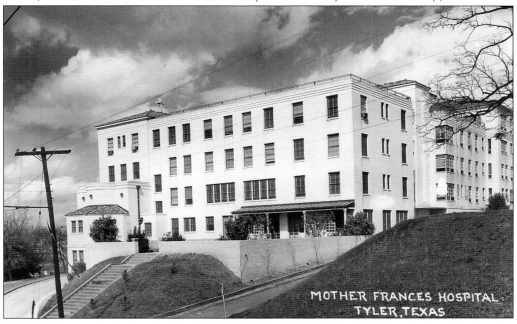

MOTHER FRANCES HOSPITAL
TYLER, TEXAS

39

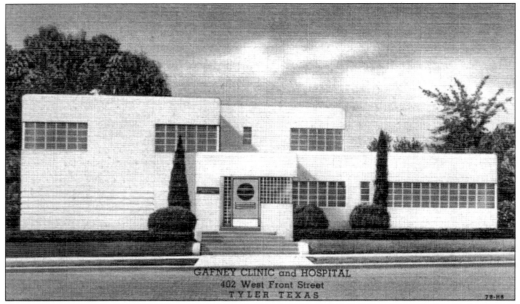

Dr. Howard Coats and Dr. Milton Gafney operated their osteopathic Coats–Gafney Clinic and Hospital in the Citizens National Bank Building until moving to 402 West Front Street in 1941. The partnership dissolved around the end of World War II, with Milton continuing alone until the early 1950s. Afterward it housed Humble Oil offices, Cotton Belt Railroad offices, Tyler Junior College health career programs, and finally People Attempting to Help. (Author's collection.)

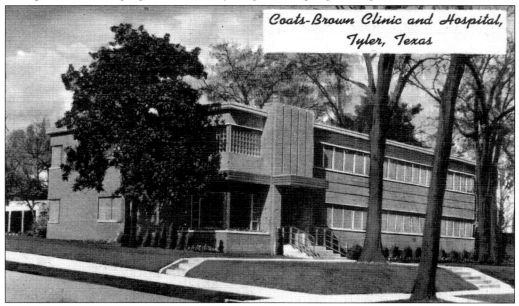

Dr. Howard R. Coats started Coats Clinic and Hospital, located at 615 South Broadway Avenue, around 1947. Dr. Joseph G. Brown became a partner around 1950. Both of them served as a physician and surgeon, and the clinic operated into the 1960s. Howard had earlier served in 1936 as the first president of Tyler Symphony Orchestra, the forerunner of the East Texas Symphony Orchestra. (Author's collection.)

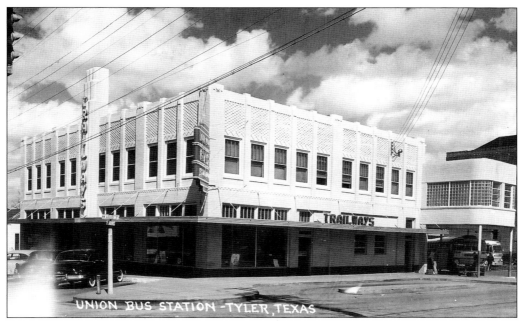

Union Bus Station was a small building to the rear of the lot on the southeast corner of North Broadway Avenue and East Line Street during the early 1930s. After the Blackstone Building was constructed on the lot, the bus depot operated out of the lobby. Around 1947, it relocated to the northeast corner of North Bois D'Arc Avenue and West Locust Street, shown above. (Courtesy Smith County Historical Society.)

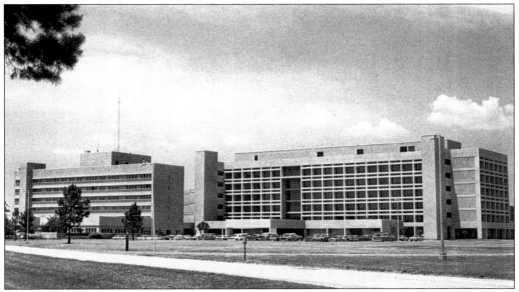

Soon after Camp Fannin closed at the end of World War II, the War Assets Administration sold the camp hospital to the state. Renovations began, and East Texas Tuberculosis Sanatorium received its first patients in July 1949. After several name changes over the years, the facility, located at 11937 U.S. Highway 271, is now called the University of Texas Health Science Center at Tyler. (Courtesy Calvin Clyde Jr.)

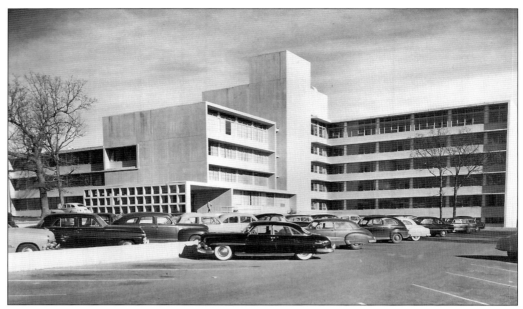

The East Texas Hospital Foundation organized in 1949 to develop Tyler as the center of regional health care. The foundation helped establish Stewart Blood Bank and Texas Eastern School of Nursing, but its largest project by far was to build Medical Center Hospital, which opened its original five-story building at 1000 South Beckham Avenue in September 1951. Partially funded with a $1-million bond approved by residents and a $500,000 federal grant, it originally had 110 beds, employed 200 workers, and even provided nurses' quarters. Through many additions and renovations over the years, it has evolved into East Texas Medical Center, a component of East Texas Medical Center Regional Healthcare System, consisting of 14 hospitals and 6,000 employees across East Texas. Both views are looking southeast, showing the original appearance of the hospital. (Above, courtesy Calvin Clyde Jr.; below, author's collection.)

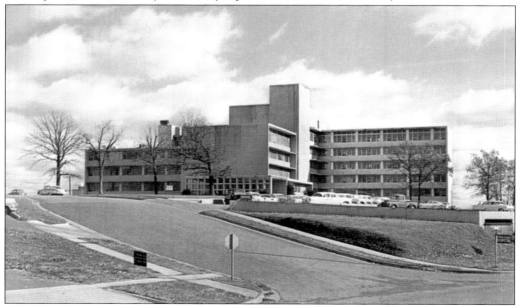

Four

EDUCATION

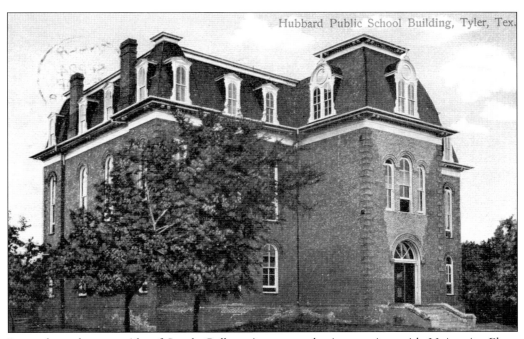

Hubbard Public School Building, Tyler, Tex.

Located on the west side of South College Avenue at the intersection with University Place, this structure, built in 1876, is reportedly the first brick school in the eastern half of Texas. It was the home of East Texas University, a private military school, through 1879. In 1882, Tyler Public School leased the building, eventually buying it in 1886 and renaming it the Hubbard Building. It was demolished in June 1913. (Author's collection.)

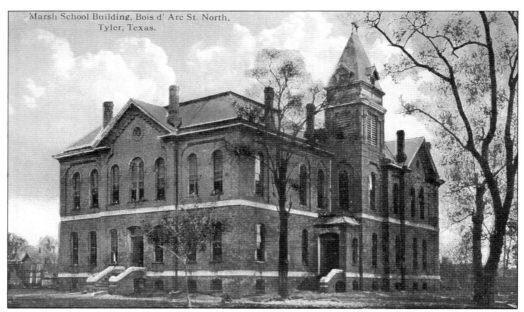

Located on the southwest corner of North Bois D'Arc Avenue and West Bow Street, North Side School was built in 1889 as Tyler's first ward school. It was later renamed Marsh School to honor Col. Bryan Marsh, a local Confederate veteran who was a Texas Ranger and Smith County sheriff for 18 years. This school was demolished in 1917 and rebuilt on the same site. (Author's collection.)

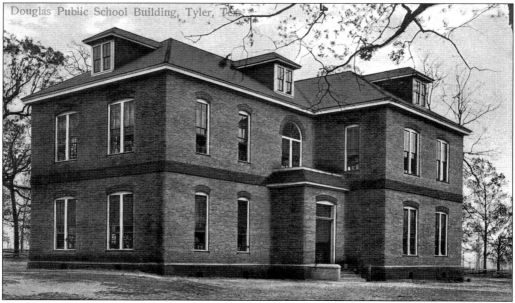

Built in 1902 near the intersection of North Beckham Avenue and East Gentry Parkway, Douglas School was named in honor of local Confederate veteran James Douglas, one of the founders of the Cotton Belt Railroad. Expanded in 1905, the school was rebuilt in 1917. In 1937, the site was abandoned and the school rebuilt at 1508 North Haynie Avenue. The school was recently totally rebuilt and opened in 2007. (Author's collection.)

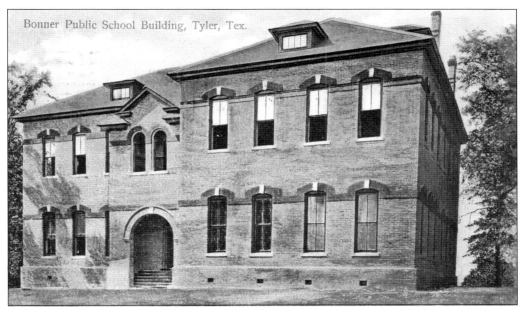

Bonner Public School Building, Tyler, Tex.

Built at 235 South Saunders Avenue in 1904, Bonner School was named in honor of Thomas Bonner, who came to Tyler in 1872 and founded the first bank. He also was elected to the Texas Legislature and later selected as Speaker of the House. Expanded in 1912, the school was totally rebuilt in 1917 but expanded again in 1931. The school was recently totally rebuilt and opened in 2007. (Author's collection.)

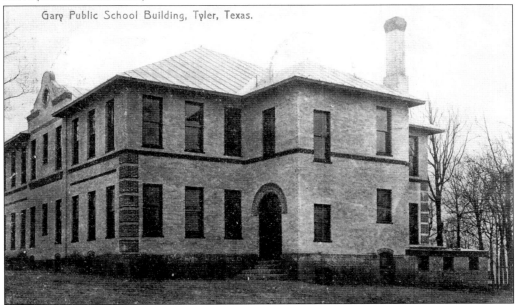

Gary Public School Building, Tyler, Texas.

Built in 1907 at 730 South Chilton Avenue, Gary School was named in honor of Franklin Newman Gary, a former teacher and district attorney for the East Texas Judicial District, later abolished. It included such modern conveniences as steam heating and indoor plumbing by use of salvaged piping and fixtures from the just demolished 1851 county courthouse. The school was demolished in 1924 and rebuilt on the same site. (Author's collection.)

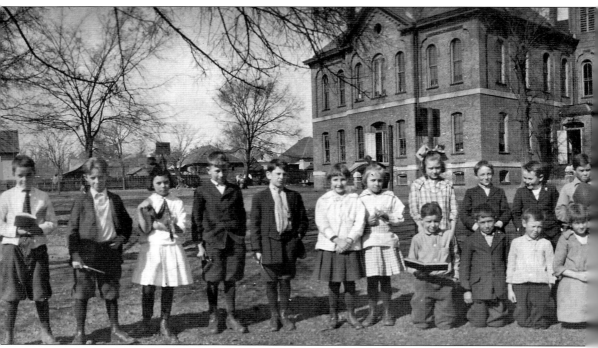

These panoramic real-photo postcards each measure 11 inches by 3.5 inches. While the above view is of a younger grade at Marsh School, the below image shows the seventh-grade room at Douglas School. None of the original four ward schools of Marsh, Douglas, Bonner, and Gary featured lighting of any kind; hence, they all had a large number of windows for daytime illumination.

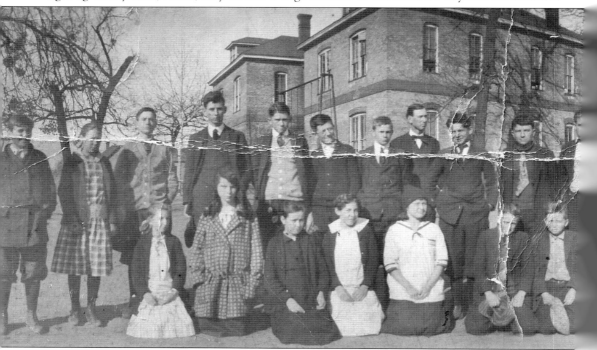

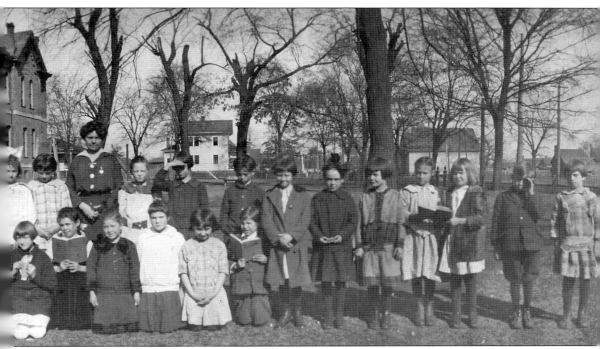

Also, all of these schools were limited to white students, for there was the West End Colored School built in 1888 and the East End Colored School established in a rented building in 1894. (Both, author's collection.)

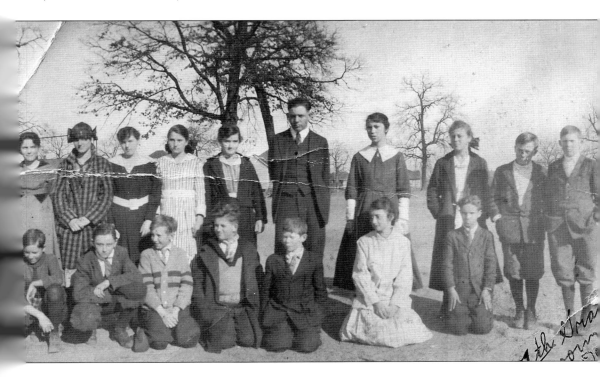

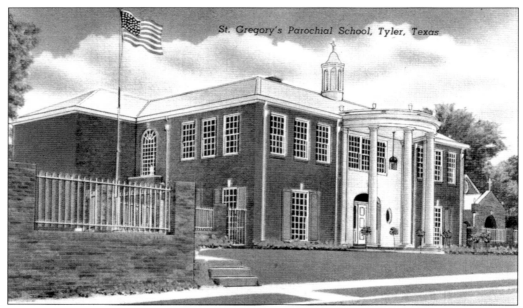

The first Catholic school in Tyler was the short-lived St. Joseph's Academy, opened around 1893. St. Gregory Elementary School, shown above, was designed by Tyler architect Shirley Simons and constructed at 500 South College Avenue. Dedicated on January 20, 1946, the parochial school was named in memory of nine-year-old Gregory Glasco, whose parents donated the land for the school. (Author's collection.)

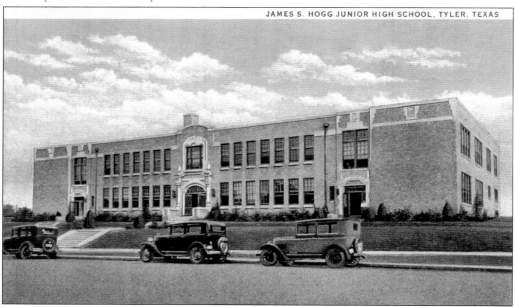

James S. Hogg Junior High School, located at 920 South Broadway Avenue, was named in honor of the first native-born Texan elected governor of the state and once resident of Tyler. The school commenced its first classes in 1929. Situated on a little under 8 acres, the original portion of the school cost just under $167,000. Noted Tyler artist A. C. Gentry once taught art at the school. (Author's collection.)

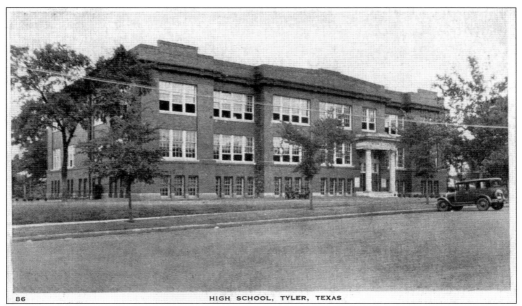

Tyler High School was built in 1912 on the northwest corner of South College Avenue and West Front Street. Often called the Hubbard Building, which actually was the name of the previous high school building that was demolished in 1913, the structure was shared with Tyler Junior College from 1926 to 1948. The campus was abandoned in the 1960s and sold to D. K. Caldwell. The building shown was later demolished. (Author's collection.)

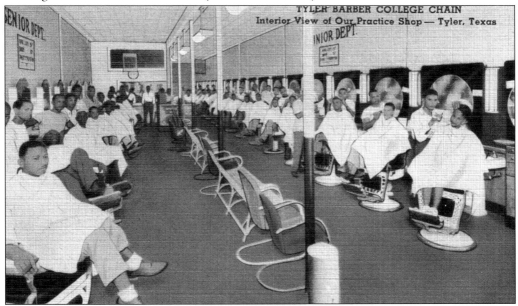

No colleges existed to train African Americans the skills required to obtain a barber's license until Henry Morgan opened Tyler Barber College, located at 212 East Erwin Street, in 1934. It became a successful chain with locations in major cities throughout the United States and reportedly featured in *Ripley's Believe It or Not!* column as a corporation headquartered in a small town with a branch in New York City. (Author's collection.)

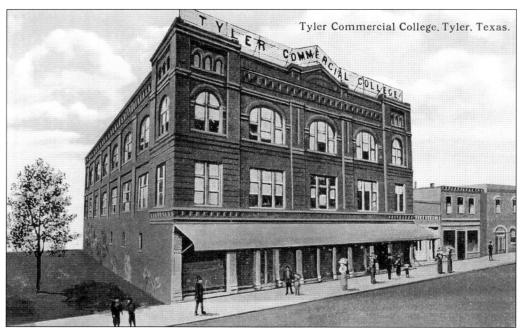

Brothers C. L. and Lockett Adair relocated their Whitesboro Teachers Normal College in the late 1890s from Grayson County to Tyler. Henry Byrne and Frank Glenn joined the brothers in the operation, then renamed Tyler College, with Henry as president. Initially the school was located on the northwest corner of South Vine Avenue and West Front Street, in the old Texas Fruit Palace. A fire in December 1903 destroyed the building, but plans began immediately for a new location. A three-story brick structure, shown above, was built at 115 South College Avenue in 1904. The top two floors were used by Tyler Commercial College, the school's new name, while Alexander Golenternek operated a furniture store on the ground level. The small building seen to the right in the view below housed Byrne Publishing Company, publisher of all the college's textbooks. (Both, author's collection.)

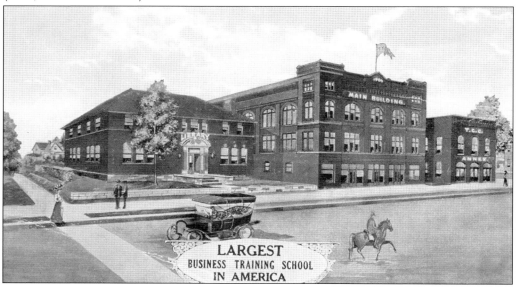

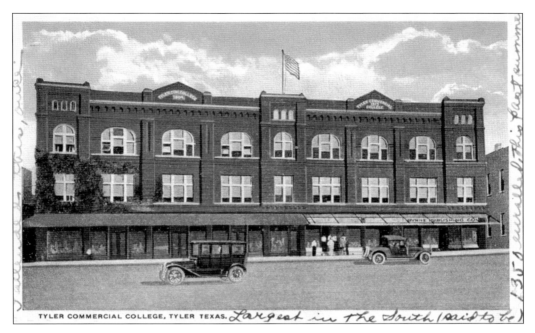

TYLER COMMERCIAL COLLEGE, TYLER TEXAS. *Largest in the South (said to be)*

While the Texas Fruit Palace had enough space for classrooms and dormitories, the new Tyler Commercial College building did not, so those needing arrangements were placed in approved boardinghouses or private residences. An attached expansion was built in 1913 on the north side, in effect cloning the first building's appearance, as shown above. As the sign shows, Byrne Publishing now operated out of the ground floor in the new portion. The below view shows the Carnegie Public Library to the left, almost implying it was part of the college. Also, a streetcar is visible to the far right of the image. From 1913 to 1917, Tyler Traction Company operated almost 7 miles of trolley line, including one along West Erwin Street as shown. (Both, author's collection.)

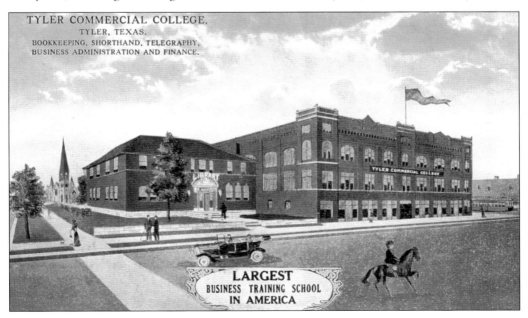

TYLER COMMERCIAL COLLEGE, TYLER, TEXAS. BOOKKEEPING, SHORTHAND, TELEGRAPHY, BUSINESS ADMINISTRATION AND FINANCE.

LARGEST BUSINESS TRAINING SCHOOL IN AMERICA

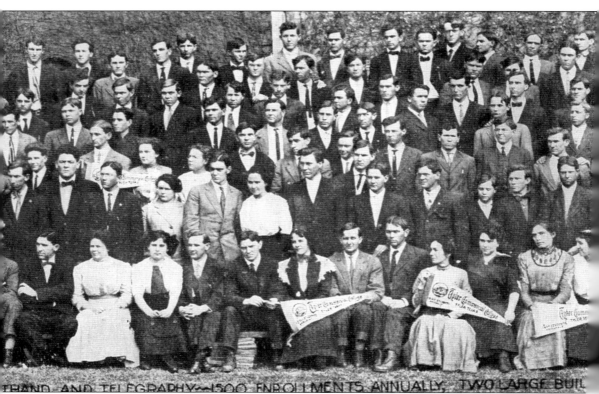

THAND AND TELEGRAPHY—1500 ENROLLMENTS ANNUALLY, TWO LARGE BUIL

The above early–1910s view of Tyler Commercial College students is a portion of a large panoramic postcard folded in four places, creating five continuous segments, each the size of a standard postcard. The overall size of the entire postcard is 27 and 3/8 inches by 3 and 3/8 inches. Shown above are segments three and four. The bottom caption, which stretches across the entire length of the postcard, reads, "Picture of students in daily attendance at Tyler Commercial College, Tyler, Texas—

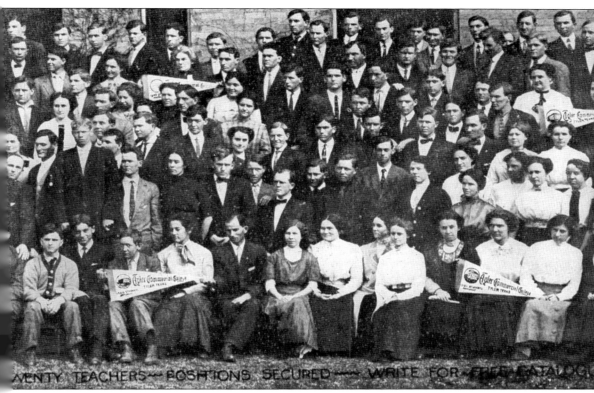

positively America's largest school of bookkeeping, shorthand, and telegraphy—1,500 enrollments annually, two large buildings—twenty teachers—positions secured—write for free catalogue." The pennants that many of the students are holding all read the same: "Tyler Commercial College Tyler, Texas 1,500 Students Annually." (Author's collection.)

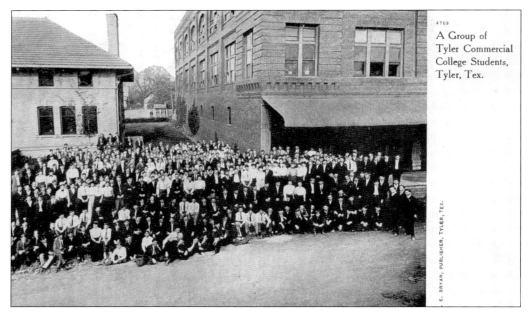

A Group of Tyler Commercial College Students, Tyler, Tex.

The above *c.* 1905 view shows a group of students in front of the Carnegie Public Library (left) and Tyler Commercial College. The below mid-1910s postcard shows a student assembly on the second floor of the original college building, with the view looking west toward the rear of the building. This may have been what was called a Saturday Program, when the students would gather on each Saturday morning for examinations, lectures, or to listen to an occasional minister. Among the business courses offered was the Byrne Simplified Shorthand, developed by college president Henry Byrne. It was claimed the students learning his copyrighted system could reach a speed of 150 words a minute in only three and a half months, a vast improvement over other shorthand systems in use. (Both, author's collection.)

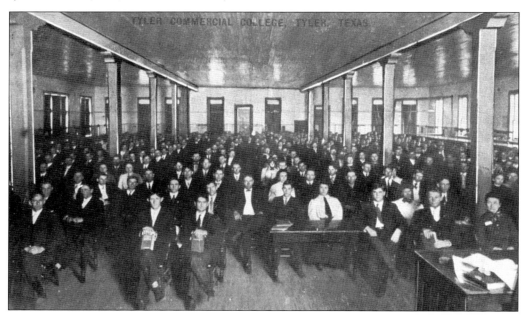

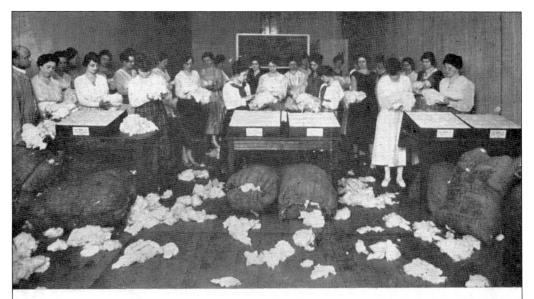

Young ladies realizing their opportunity of preparing to take the place of their brothers who are fighting, by learning Cotton Classing in the Tyler Commercial College, the only school having a special Cotton Classing Department for ladies

The above late-1910s view shows Tyler Commercial College's cotton classing training. The school was the only one with a special class for women, which filled a real need when the men were away fighting in World War I. Classes in radio telegraphy and telephony started in the 1920s, and the college actually provided radio-operation training as a Signal Corps school during World War II, teaching 2,000 army staff from April 1942 to July 1943. The below view shows a social gathering in the third-floor "auditorium" in the newer half of the building. When Tyler permitted 3.2-percent beer and wine sales in the 1930s, this space was rented for public dances with live bands. The college moved to 235 South Broadway Avenue around 1955 and closed a few decades later. The College Avenue building was demolished around 1963. (Both, author's collection.)

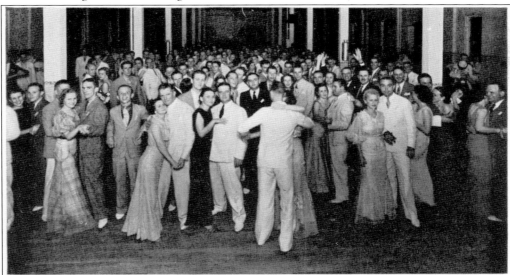

TYLER COMMERCIAL COLLEGE ROOF GARDEN CENTER OF STUDENT RECREATIONAL ACTIVITIES.
REGULAR WEEKLY SOCIAL EVENT. CHARLIE AGNEW AND HIS YEAST FOAMERS.
TYLER, TEXAS A-829

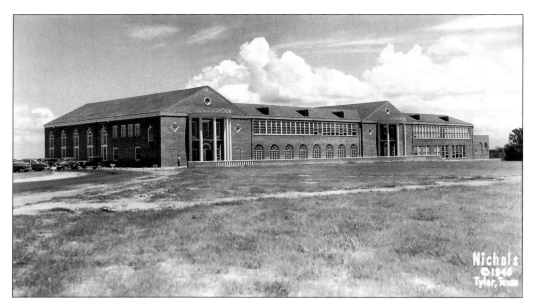

Tyler Junior College was established in 1926 as part of the public school system, and it shared the high school campus. Later voters overwhelmingly approved creating a junior college district, and in 1946, it separated from the public school system. A new campus was ready in summer 1947, comprised of moved surplus buildings from Camp Fannin, a nearby army training facility that closed after World War II. The first new building constructed, shown above, was completed in February 1949, later to be renamed Jenkins Hall. A band and a girls' drill team were created in 1947. The band was organized by "Doc" Witt, formerly director at Tyler High School. Originally called the Apache Roses but soon renamed the Apache Belles, the drill team was organized by Mildred Stringer. The Belles are shown below, performing in Tyler's Rose Stadium during the Texas Rose Festival. (Both, author's collection.)

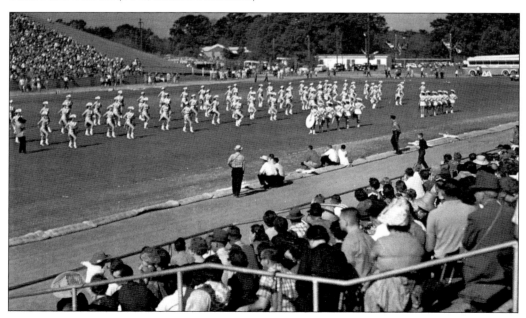

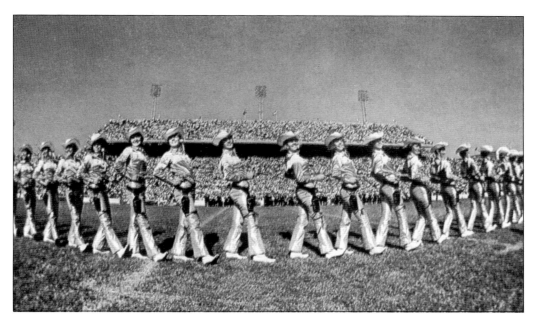

Al Gilliam, a past Tyler High School head cheerleader, was hired as the dance director of the Apache Belles in 1948. At a 1949 Tyler Junior College football game against Paris Junior College, Cotton Bowl officials observed the Apache Band and Belles and soon invited them to represent the Southwest Conference at a Cotton Bowl game in Dallas, the start of a tradition. When the Dallas Cowboys formed, the Belles became regular performers for several Cowboys halftime shows each year. Shown above are the Belles performing during a Cowboys halftime in the Cotton Bowl. Marsha Gimble is shown below with the Apache Band practicing in the Los Angeles Coliseum for an upcoming halftime show for a *c.* 1969 Cowboys and Los Angeles Rams game. Gimble was the band drum major, as well as an Apache Belle. (Both, author's collection.)

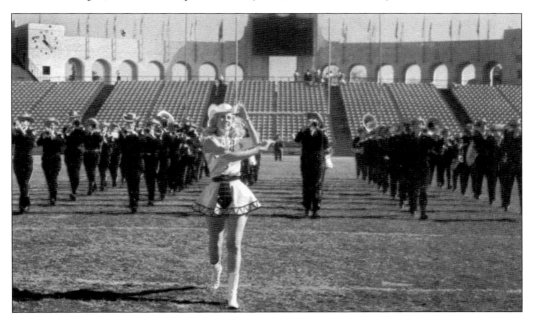

SCENES ON THE CAMPUS, TEXAS COLLEGE, TYLER, TEXAS

After a decade of dedicated work, the Colored Methodist Episcopal Church succeeded in establishing an African American college in 1894. Texas College, located at 2404 North Grand Avenue, began with only a four-room frame structure, one teacher, and six students. It offered basic high school classes such as arithmetic, grammar, and geography, as well as vocational and normal courses. By 1905, college-level courses were taught. The school renamed itself Phillips University in 1909, only to return to Texas College in 1912. It became an accredited junior college in 1924 and an accredited senior college in 1932. The Texas College Steers football team was undefeated in 1934 and won the black Southwest Conference. Another undefeated year in 1935 ended with the team winning the national championship against the Alabama State College Hornets in Tyler Stadium. (Both, author's collection.)

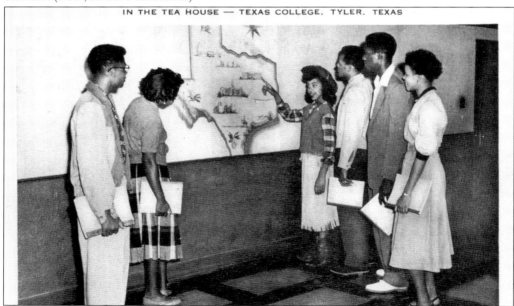

IN THE TEA HOUSE — TEXAS COLLEGE, TYLER, TEXAS

Five

RELIGION

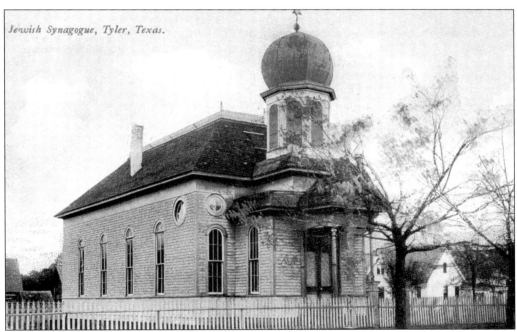

Congregation Beth-El, chartered in April 1887, dedicated their first synagogue, shown above, on June 16, 1889. Located on the northeast corner of the South College Avenue and University Place intersection, it was remodeled after a March 1914 fire and eventually razed in May 1937. Their second temple, dedicated in September 1938, served them until they once again moved in 1990 to 1010 Charleston Drive. (Courtesy Smith County Historical Society.)

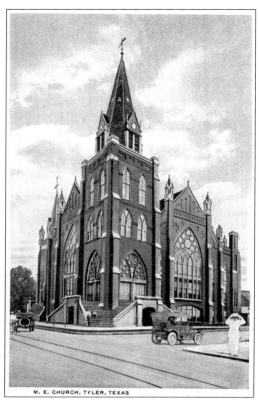

M. E. CHURCH, TYLER, TEXAS

The first organized Smith County congregation of any denomination was the Methodist Episcopal Church South at Tyler, formed in 1848. The first leader of the church was Rev. Alexander Douglas. The group met in their first church from 1852 to 1889, a frame building they shared with St. John's Masonic Lodge No. 53. In 1891, the congregation completed and moved into their present church at 300 West Erwin Street and renamed itself Marvin Methodist Church, in honor of Bishop Enoch Mather Marvin. In January 1898, lingering construction debt forced the church to be sold at auction on the courthouse steps. Kettie L. Sample, a widowed daughter-in-law of Reverend Douglas, bought the building for $9,500. She rented it back to the congregation, and the church regained ownership from her in December 1899. (Left, author's collection; below, Tyler Public Library.)

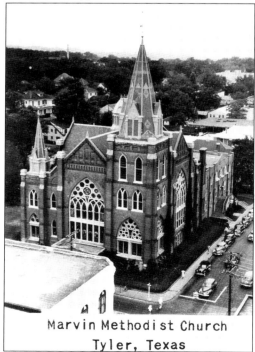

Marvin Methodist Church
Tyler, Texas

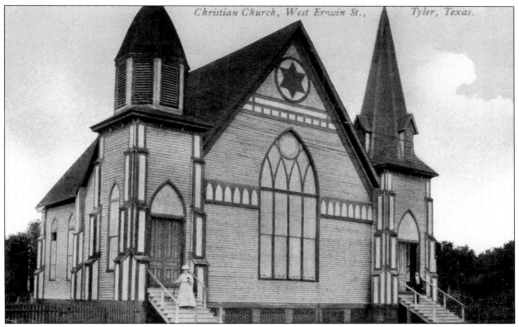

A Christian church existed on the southeast corner of North Broadway Avenue and West Locust Street around 1860, but the congregation had no minister, relying on lay members for most services. During the Civil War, the church became "disorganized" and dissolved. In 1889, a rebirth occurred when a group officially organized as the First Christian Church. They built a church at 401 West Erwin Street, shown above, in 1893. It was a one-room structure, but a basement was later excavated. Growth required a new home, shown below, which was dedicated on August 19, 1928, on the southwest corner of South Broadway Avenue and University Place. This building served the congregation until it moved to 4202 South Broadway Avenue in 1965. The September 19 service started at the old church and then became a motorized procession to the new location, where the service concluded. (Both, author's collection.)

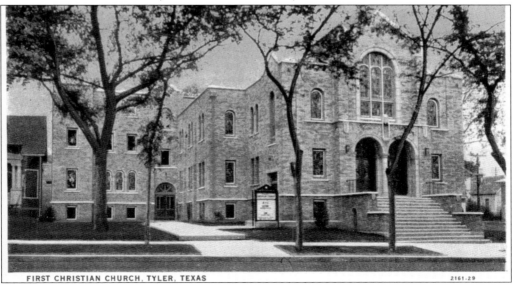

FIRST CHRISTIAN CHURCH, TYLER, TEXAS 2161-29

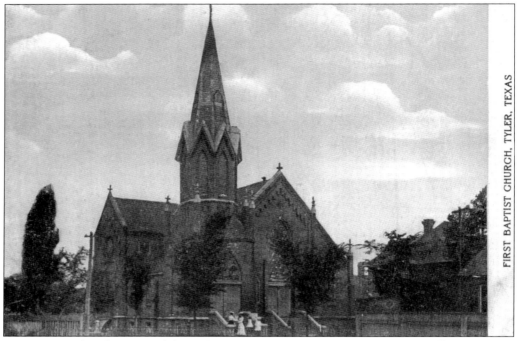

First Baptist Church is one of the earliest Baptist churches organized in Texas still in existence. Organized in April 1848, and officially chartered in 1882 as Baptist Church of Tyler, its name became First Baptist Church of Tyler in 1888. Construction of their first church started in 1855 on the north side of East Ferguson Street, near the International and Great Northern Railroad crossing, but it burned before completion. After rebuilding in 1859, another fire in 1882 and railroad noise prompted the congregation to move. Above is the new red-brick church occupied in 1886 on North Bois D'Arc Avenue. In 1913, the congregation moved to an adjacent new building located on the northwest corner of North Bois D'Arc Avenue and West Ferguson Street, shown below with the previous church still visible beyond it. (Above, author's collection; below, courtesy Mary Love Berryman.)

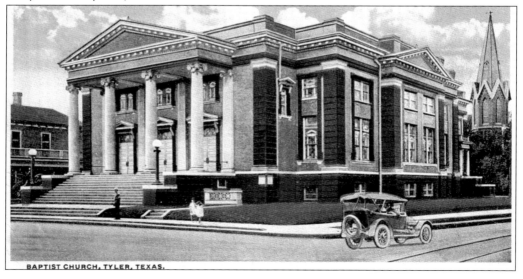

BAPTIST CHURCH, TYLER, TEXAS.

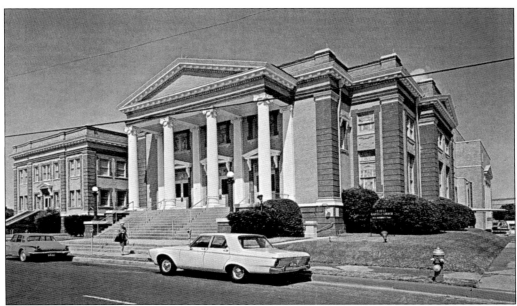

First Baptist Church dedicated the Lillie Belle Wright Education Building in November 1937. Seen to the left of the church in the above view, it was partially funded by income from a donated oil well. The previous church was eventually demolished and replaced by a new education building, dedicated in June 1959 and seen in the right background. (Courtesy Mary Love Berryman.)

Some of the First Baptist Church members felt that it had grown too large and was becoming impersonal. Deacon W.V. Henson decided to form a new congregation, originally meeting in the basement and also the old church building. A mission church was built at 1607 Troup Highway, where Green Acres Baptist Church held its first service in January 1955. (Courtesy Calvin Clyde Jr.)

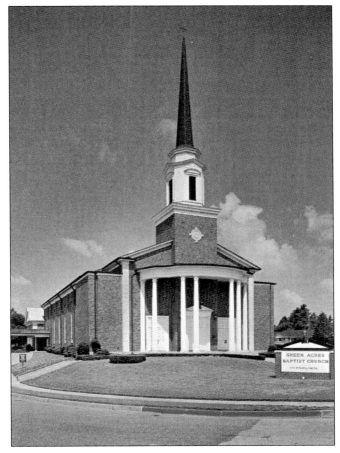

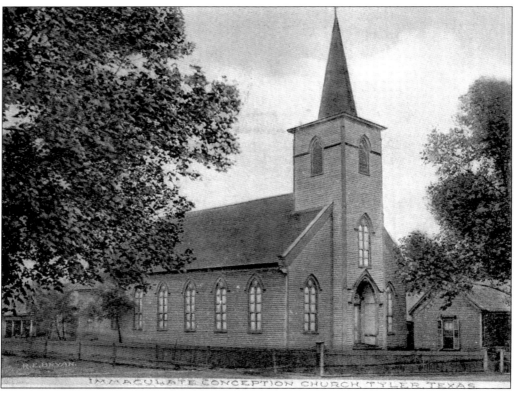

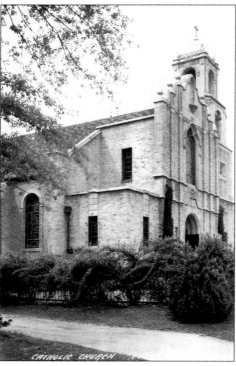

While mass had been celebrated for a number of years before, the first Catholic church was dedicated in 1882 on the northeast corner of North College Avenue and West Locust Street, shown above. It was called Church of the Immaculate Conception, with French Rev. J. S. Chaland preaching to a mainly Irish congregation employed by the railroad. After a fund collection drive of 15 years, construction started in 1934 on a new church, shown at left, on the southwest corner of South Broadway Avenue and West Front Street. The parish, now known as Cathedral of the Immaculate Conception, was so eager to move in that it actually did by Christmas 1934, before construction was completed. The actual dedication occurred on March 17, 1935. Soon afterward, the 1882 frame church was moved to West Lollar Street for use as a mission parish. (Both, author's collection.)

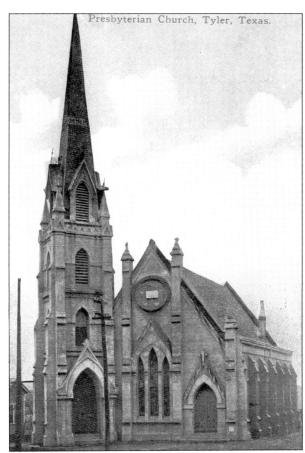

Presbyterian Church, Tyler, Texas.

Built around 1883, First Presbyterian Church, shown at right, was located at 315 West Ferguson Street and featured a 90-foot steeple. A stand-alone Sunday school room was built behind the church soon after 1907. Around 1910, the leaders of First, Cumberland, and Central Presbyterian Churches met and decided to unite their congregations into one, using the name First Presbyterian Church. They constructed a new church, shown below, on the southwest corner of South Broadway Avenue and West Elm Street. The original First Presbyterian Church on West Ferguson Street was demolished and replaced by an apartment building, which later became part of First Baptist Church. The combined Presbyterian congregation remained on South Broadway Avenue until 1950, when they moved into a larger, new church at 230 West Rusk Street, their current location. (Both, author's collection.)

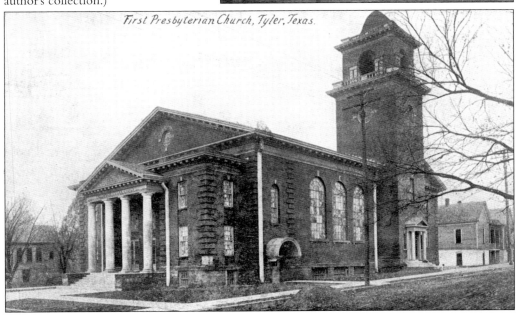

First Presbyterian Church, Tyler, Texas.

Organized in 1867, Christ Episcopal Church had as its first permanent rector exiled Hungarian nobleman Emir Hamvasy, who arrived in 1872. Its first church was a frame structure with a steeple that faced east on the northwest corner of North Bois D'Arc Avenue and West Locust Street. The congregation moved to the northeast corner of South Bois D'Arc Avenue and West Elm Street, shown above, in 1918. (Courtesy Bill and Sue Corbin.)

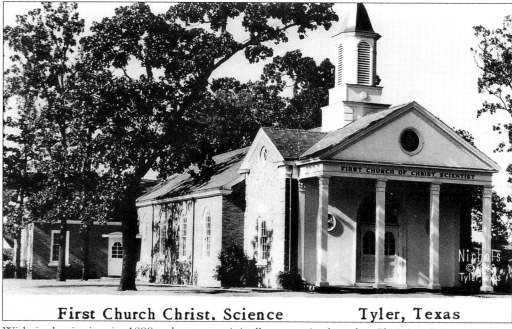

With its beginning in 1899, what was originally recognized as the Christian Science Society became the First Church of Christ, Scientist in 1931. Their first church was at 315 West Front Street from 1929 to 1948. Their second location, shown above, is at 106 East Second Street, where the first service was held on January 16, 1949. A wing was added to enlarge Sunday school facilities in 1964. (Author's collection.)

Six

RESIDENCES

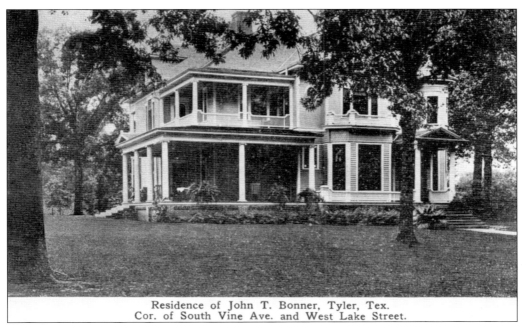

Residence of John T. Bonner, Tyler, Tex.
Cor. of South Vine Ave. and West Lake Street.

Attorney John T. Bonner's home, located at 625 South Vine Avenue, was built around 1872 on the former homestead of his father, Thomas Reuben Bonner, once Speaker of the Texas Legislature. The house was originally a two-story structure; however, an electrical fire in 1926 destroyed the second floor, and the house was restored as the one-floor building seen today. (Author's collection.)

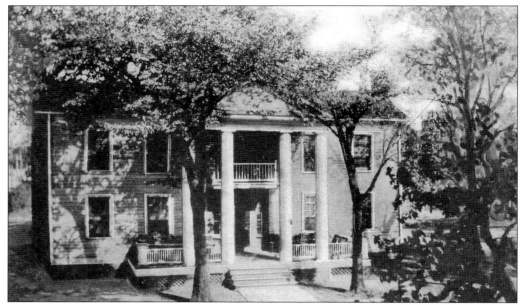

Franklin N. Gary, an early Tyler lawyer, built this house before the Civil War on the northeast corner of North Bois D'Arc Avenue and West Ferguson Street. When the Federal Building was to be constructed on the site in 1886, the house was moved the length of the block north and rotated to face west at 225 North Bois D'Arc Avenue. (Courtesy Smith County Historical Society.)

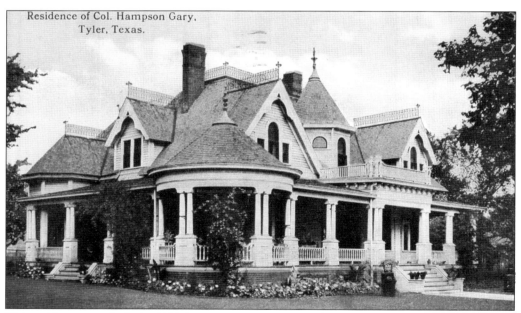

This residence was built in 1901 by Hampson Gary on South Broadway Avenue, just south of University Place. Like his father, Franklin N. Gary, Hampson was a lawyer, and he later became U.S. Minister to Egypt in 1917 and to Switzerland in 1920. In the 1920s, First Christian Church bought the house and large lot, using the house as a parsonage, and in 1928 built a church on the lot. (Author's collection.)

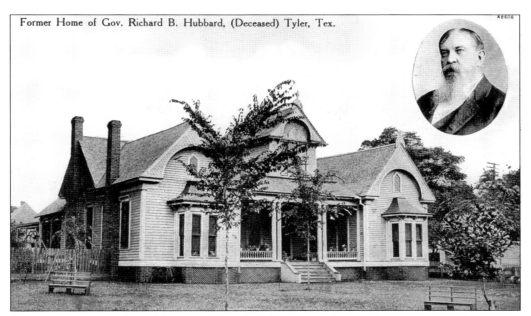

Former Home of Gov. Richard B. Hubbard, (Deceased) Tyler, Tex.

This postcard shows the residence of Richard B. Hubbard, a former Texas governor who appears in the upper right corner. The house was located on the land between East Locust Street and East Ferguson Street and between North Center Avenue and North Fannin Avenue. Hubbard bought the house in 1876, and he most likely resided there 1879 to 1885 and from 1889 until his death in July 1901. (Author's collection.)

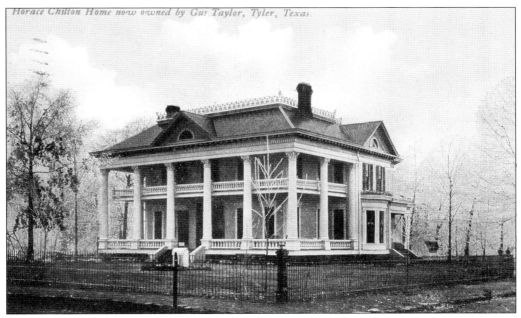

Horace Chilton Home now owned by Gus Taylor, Tyler, Texas

This house was built in 1888 at 727 South Chilton Avenue by Horace Chilton, the first native-born Texan to serve as a U.S. senator. Purchased in 1910 by Gus Taylor, it housed his family for 45 years. D. K. Caldwell bought it in 1955 for use as Caldwell Playschool No. 2, which closed in 1998. In January 2005, it was purchased for Southwest Operating Company offices. (Author's collection.)

The John Durst home stood on the northwest corner of South Beckham Avenue and East Front Street. John was a land speculator and developer. The Grand Opera House was one of his joint ventures with Rudolph Bergfeld. Among other things, John was also a part owner of the Tyler Car and Lumber Company, a partner in the Tyler Electric Light and Power Company, and served 14 years as a city commissioner. (Author's collection.)

4487 A Southern Home, Tyler, Tex.

One of the Many pretty Homes, Tyler, Texas.

Julius and Johanna Pabst emigrated from Prussia to Tyler around 1856. Julius, a tanner by profession, died in 1887. Johanna bought the house and adjoined lot located on the southeast corner of South Fannin Avenue and East Noble Street, shown above, from Y. R. Frazier in 1897. After her death, her children, Albert Pabst and Julia Pabst Willett, inherited the home. Later the house was separated into apartments. (Author's collection.)

L. L. Jester built this house in 1898 at 630 South Fannin Avenue. He was one of the founders of Tyler National Bank in 1892, which later became Peoples National Bank. His wife, Minnie, was a popular local musician and vocalist. They sold the house in 1912 to Judge Thomas B. Butler, founder of T. B. Butler Publishing Company and owner of the newspaper that evolved into today's *Tyler Morning Telegraph*. (Author's collection.)

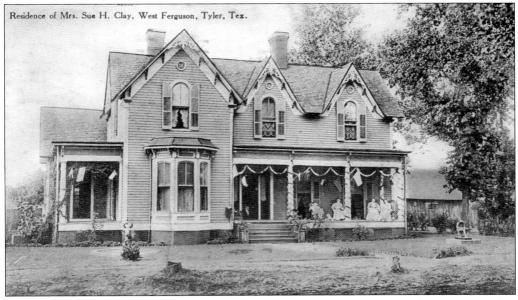

Widow Sue H. Clay lived in the house at 403 West Ferguson Street, shown above. In 1900, her single sons Benjamin, James, and William lived with her, with Benjamin and James working as railroad clerks. By 1910, both of them had moved out, but William and his wife, Harriet, continued to live with his mother, Sue, while he worked as a grain merchant. (Author's collection.)

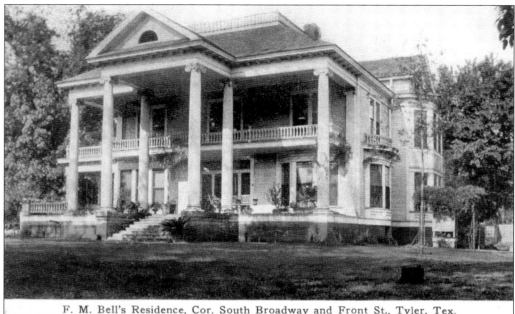

F. M. Bell's Residence, Cor. South Broadway and Front St., Tyler, Tex.

Shown above is the home of Frank and Sarah Bell, built in 1900 on the southwest corner of South Broadway Avenue and West Front Street. Their son Henry inherited the house, and it remained in his family until 1960. When demolition seemed likely, it was moved to a location south of Tyler on County Road 134 and restored in 1974. It became a recorded Texas Historic Landmark in 1978. Bryan and Mary Bell's house, below, was on South Broadway Avenue immediately south of the home of his younger brother, Frank. In earlier days, Frank and Bryan attended Louisiana State University together in 1871. In 1872, while Frank was continuing his education in Lexington, Virginia, Bryan was a bookkeeper for Roberts and Lindsey, earning $50 a month. (Both, author's collection.)

A Residence on Broadway, Tyler, Tex.

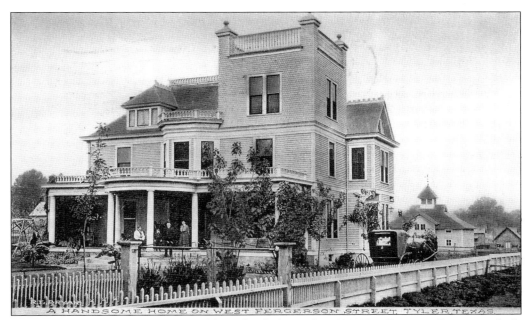

The residence of the Dr. Aaron P. Baldwin family, located at 431 West Ferguson Street, was built around 1905. North Bonner Avenue was extended north along the west side of the house in the 1930s, and the structure became city hall. After a new city hall was built across the street in 1939, it became a community center. It was demolished around 1970. (Author's collection.)

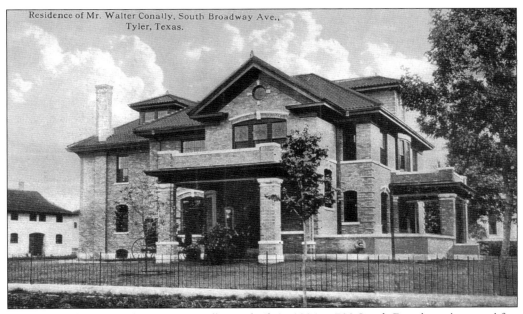

The home of Walter and Gretta Connally was built in 1906 at 700 South Broadway Avenue. After Walter's death in 1918, his widow continued to live in the house with a son and his wife. It remained in the Connally family for over 70 years. John and Ellen Musselman began restoration of the house in 1978, and it became a recorded Texas Historic Landmark in 1983. (Author's collection.)

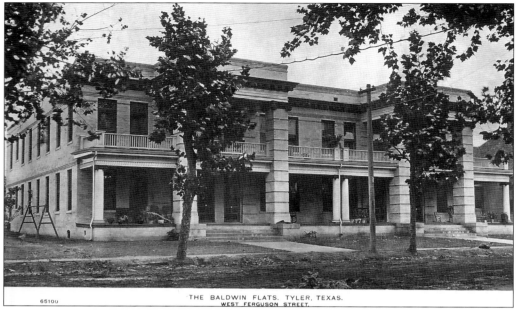

THE BALDWIN FLATS, TYLER, TEXAS.
WEST FERGUSON STREET.

65100

The Baldwin Flats were apartments at 410–420 West Ferguson Street, with a coal and wood shed running across the backyard. A 1909 edition of the *Daily Courier-Times* writes of them, saying "almost the exact spot of the swimming hole (of long ago) is now occupied by the Baldwin Flats, whose substantial masonry, graceful proportions and elegant finish is in marked contrast with the scenes of former times." (Courtesy Smith County Historical Society.)

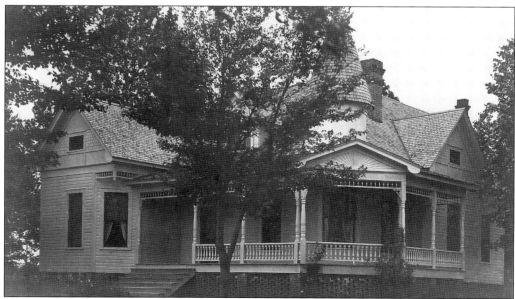

The message on this real-photo postcard, mailed to Boulder, Colorado, reads, "Tyler, Texas, June 15, 1913. This is a picture of our 'country home'. We are both feeling fine and like this country. Would be pleased to have 'you all' come and see us." It is signed "The Latimers." (Author's collection.)

Seven

FESTIVALS, FAIRS, AND PARADES

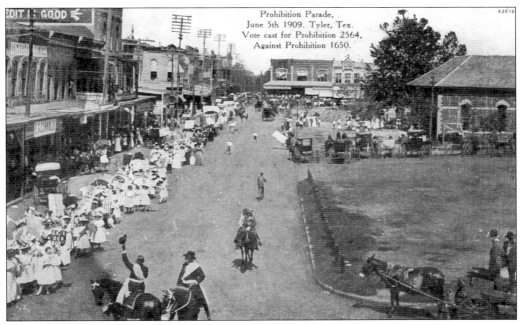

Shown is the Prohibition Parade held on June 5, 1909. The postcard is looking east along Ferguson Street, from the intersection with North College Avenue, and states that the votes cast for Prohibition were 2,564, with 1,650 votes against. This must have been a revote, for Prohibition was achieved in Smith County in 1901, long before the 18th Amendment imposed it nationwide in 1919. (Courtesy Bill and Sue Corbin.)

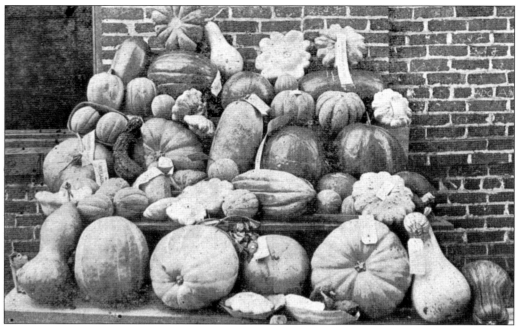

The first East Texas Fair was held October 6–8, 1910, and some of its agricultural exhibits are shown on these two postcards. For the first two years, the fair was held downtown on the courthouse square, but later acreage was purchased for a permanent site at the West Front Street location, where the fair has been held since 1912. Opening day parades continued to circle the downtown square for years. At times, the fair also included fireworks and hot-air balloon ascensions, as well as horse and automobile races. The city extended electricity and streetcar service to the new fairgrounds in 1913. Called the East Texas State Fair today, it has future plans to move to a larger location purchased in 2005 outside of West Loop 323. (Both, author's collection.)

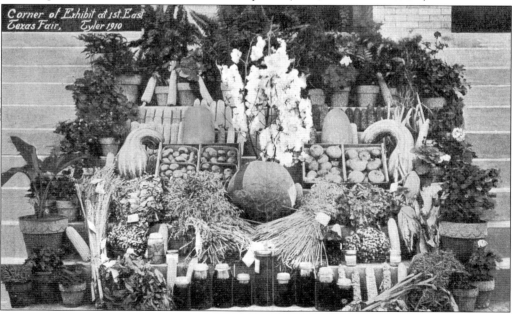

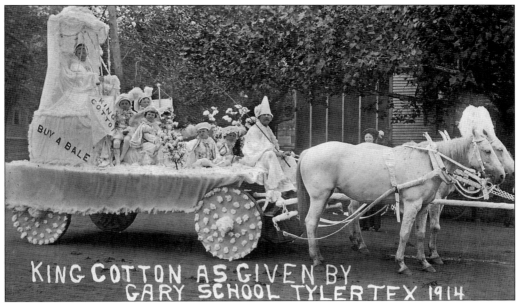

This is the winner of the best decorated float, school category, in the 1914 East Texas Fair parade. The demand for cotton had dropped, lowering the prices, which in turn affected the income of other businesses. This float supported the "Buy a Bale" movement sweeping across the South, which encouraged individuals to buy bales and store them in public cotton warehouses until the prices improved. (Courtesy Smith County Historical Society.)

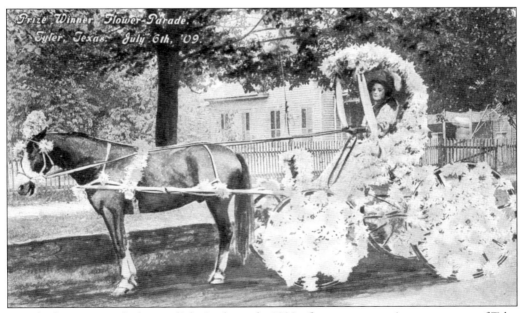

Even before roses took the spotlight in the early 1930s, flowers were an important part of Tyler parades. Shown is a prize-winning entry in the Flower Parade of July 6, 1909. This one-horse buggy, driven by a woman, is totally covered in flowers, with additional ones strategically placed on the horse itself. (Author's collection.)

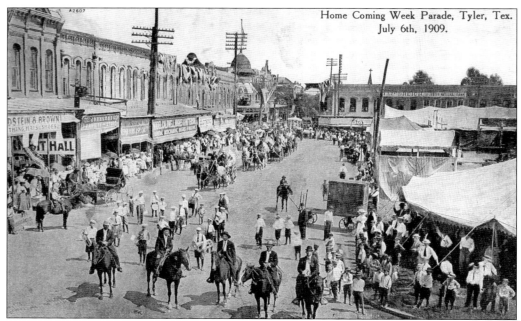

Both of these postcards show the July 6, 1909, parade, as it travels south on North College Avenue and turns east onto West Erwin Street. Tents cover the west side of the public square. Business signs visible include Goldstein and Brown; Johnson's; Wadel, Caldwell, Hughes, and Patterson; Mayer and Schmidt; I. Liebreich; and Jester National Bank. The above view calls the event the Home Coming Week Parade, and just behind the horse and riders in the foreground is the Tyler Kid Band. Next in line are the three horse-drawn components of the fire department, shown in the foreground of the view below, which refers to the event as the Flower Parade. The fire department participants are led by Chemical Engine No. 1, driven by Assistant Chief M. P. Burns (left) and Chief J. J. Daglish (right). (Both, author's collection.)

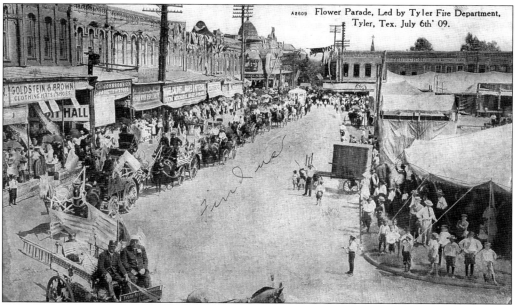

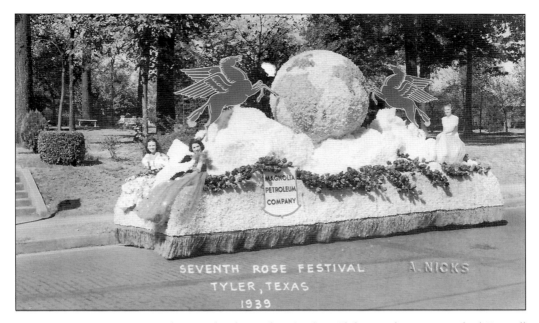

In August 1933, Marion Wilcox and other Tyler Garden Club members approached Russell Rhodes, the chamber of commerce manager, to insist he somehow publicize local rose growing. With assistance from local attorney Thomas Ramey, the effort evolved into the Rose Festival, with Thomas as the first president. The festival dates were set for October 11–12, leaving only six weeks to get it organized. Starting the first day at 2:30 p.m., a 2-mile-long parade circled the downtown square. It is interesting to note that the Rose Queen, Margaret Copeland, was not chosen until that night, and her afternoon coronation occurred on the last day in Bergfeld Park. Both of these postcards show 1939 Rose Parade floats; the above one was sponsored by Magnolia Petroleum Company, while below is Rose Queen Dorothy Bell's float. (Above, courtesy Smith County Historical Society; below, courtesy Tyler Public Library.)

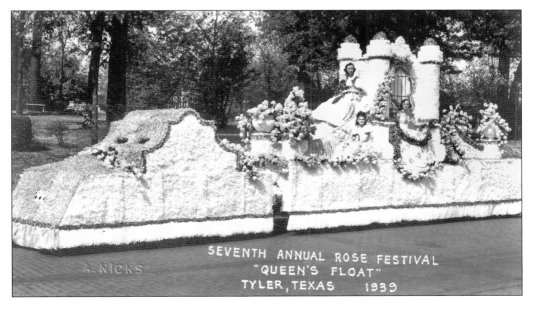

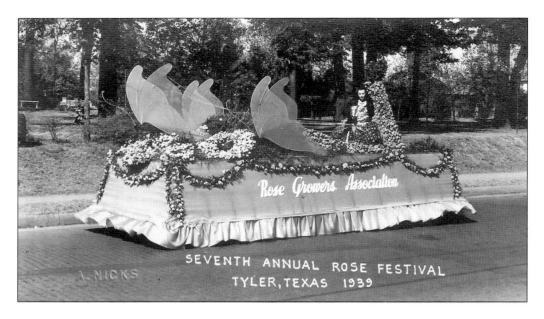

More Rose Festival facts of interest are as follows: the first queen coronations occurred at Bergfeld Park, were later moved to Caldwell Auditorium, and today are held at the Cowan Fine and Performing Arts Center at the University of Texas at Tyler; the festivals held from 1935 to 1941 featured a collegiate football game, with the first being between Texas A&M University and Temple University; the festival was not held from 1942 to 1946 inclusive because of World War II; and the parade was a downtown event until 1949, when the route was changed to start on West Front Street and conclude at the newly completed Rose Stadium. The above 1939 Rose Parade float was sponsored by the Rose Growers Association, while below is the 1940 float sponsored by S. G. Fry menswear store. (Both, author's collection.)

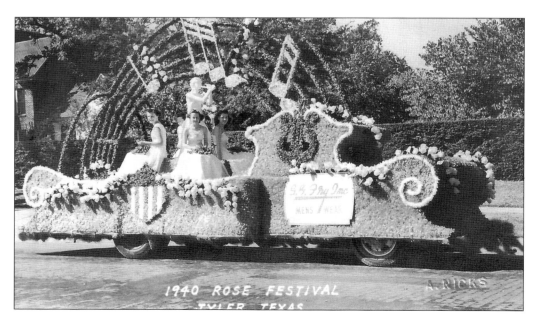

At the first Rose Festival in 1933, a Rose Show was not listed on the program and was literally set up at the last moment in a downtown vacant building. A few cut roses were displayed in bottles, and there were just a couple of arrangements. The 1934 Rose Show general chairman, Carolyn Hanley, patterned the second festival's display after a Portland, Oregon, Rose Show she saw. Thousands of visitors admired the displays of 500 different rose varieties, which was open on both days in a downtown building. These two postcards are Rose Shows from decades later, held in Garden Center Building at the Tyler Municipal Rose Garden. (Both, author's collection.)

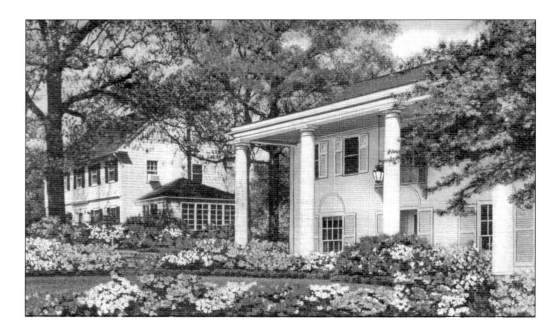

Tyler nurseryman Maurice Shamburger planted an azalea test garden in 1929. The colorful shrubs adapted well to East Texas, and he soon discussed with Sara Butler, owner of the *Tyler Courier-Times-Telegraph*, the promotion of azalea plantings throughout the city. Sara encouraged his crusade and even planted them around her Charnwood Street residence. Within a decade, many of the residential gardens of the brick-street area were awash in springtime color. The above mid-1950s postcard shows the front lawn of 121 Lindsey Lane, while the below *c.* 1940 postcard shows a backyard garden. (Both, author's collection.)

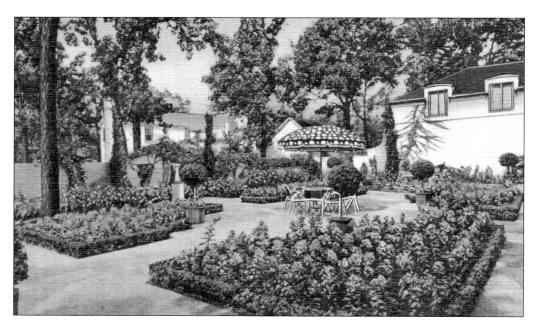

For decades, each spring brought an abundance of azalea-bloom colors to many of the residences in the old brick-street neighborhoods. The increase of tourism during those weeks was noticed by the chamber of commerce. To encourage visitors, the chamber launched in 1960 the first Azalea and Spring Flower Trail, which highlighted a 5-mile stretch of about 60 homes. In 1963, a second trail was added through the Green Acres area, but it was discontinued when it was not as popular. Today there are two trails: Lindsey Trail, which is the original route, and Dobbs Trail, which follows portions of the other route but includes additional spectacular floral displays. Both of these postcards show the garden on the northwest corner of South Broadway Avenue and Lindsey Lane, with the south side of the Woman's Building in the background. (Both, author's collection.)

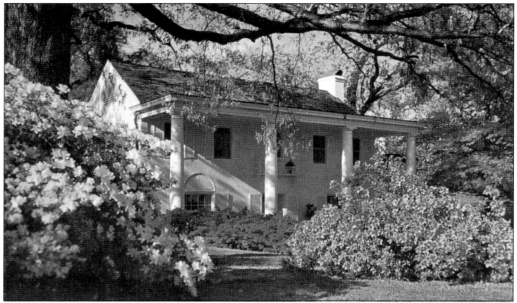

Not just azaleas bring beauty to the spring event, but also dogwoods, wisteria, daffodils, tulips, and other flowering plants contribute to the dazzling displays that make up the Azalea and Spring Flower Trail. In 1964, the chamber of commerce came up with the idea of young women wearing antebellum dresses stationed along the route. Called Azalea Belles, these greeters were originally secretary staff from the chamber offices. This tradition continues, but the Belles are Tyler high school students today. As attendance for the Azalea and Spring Flower Trail increased, annual shows were organized during the same period, including porcelain art, fine art, quilts, and arts and crafts. The above postcard shows the beautiful front lawn of 121 Lindsey Lane, while the below view is of another backyard garden. (Above, courtesy Calvin Clyde Jr.; below, author's collection.)

Eight

BUSINESSES

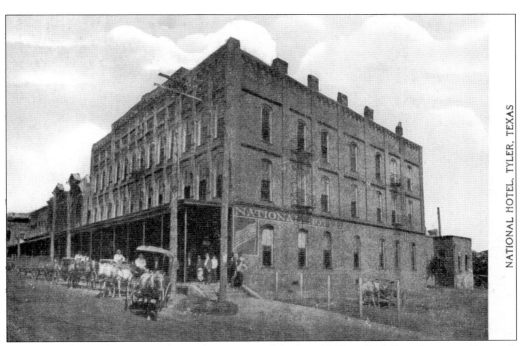

NATIONAL HOTEL, TYLER, TEXAS

This view shows the National Hotel, constructed in late 1889 at 212 East Ferguson Street. It became the Hotel Tyler in the mid-1910s and saw much business during the 1930s East Texas oil boom, as did all local hotels. It became the Milner Hotel in its final years, closing in the mid-1950s and soon afterward being demolished. (Author's collection.)

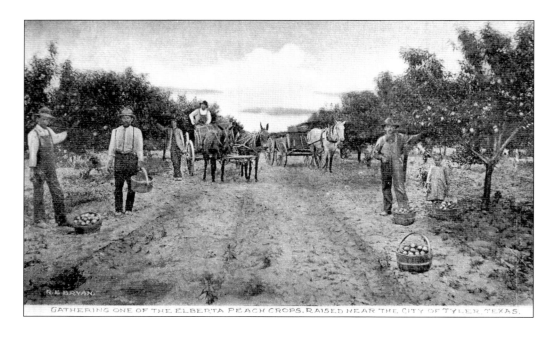

GATHERING ONE OF THE ELBERTA PEACH CROPS, RAISED NEAR THE CITY OF TYLER, TEXAS.

Truck farming is the cultivation of fruit or vegetable crops for transport to distant markets where they cannot be grown because of the climate. In Tyler's case, most of the crops were canned or iced down and shipped northward on the Cotton Belt Railroad. One of the early important truck crops for the area was peaches. Shown on both of these postcards is the gathering of Elberta peaches. In 1889 alone, Smith County harvested 104,283 bushels of peaches. However, disaster loomed on the horizon, arriving just after the next century started. San Jose scale, a major peach blight, soon struck, and by 1914, all peach orchards were killed. Most peach growers switched to the growing rose industry. (Both, author's collection.)

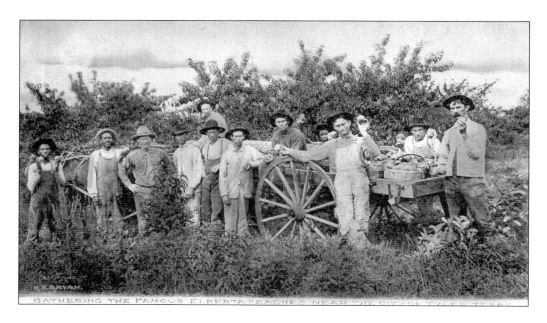

GATHERING THE FAMOUS ELBERTA PEACHES NEAR THE CITY OF TYLER, TEXAS.

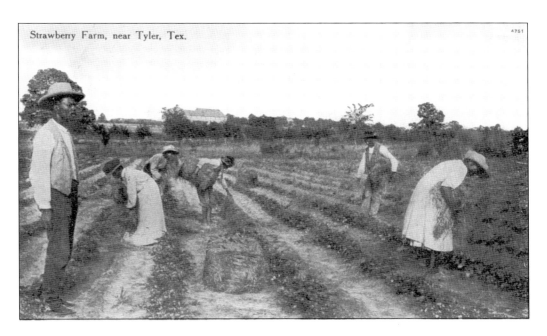

Another of the early important truck crops for the area was strawberries, shown on both of these postcards. By 1909, Smith County was growing more strawberries than all the other counties in the state combined. In 1895, the Texas Fruit Palace was built on the northwest corner of South Vine Avenue and West Front Street by local businessmen to showcase Texas fruit production. However, its annual two-week-long expositions were so extravagant that the group went bankrupt after only the second event in 1896. A fire unfortunately destroyed the beautiful building in December 1903, which at the time was housing the forerunner of Tyler Commercial College. (Both, author's collection.)

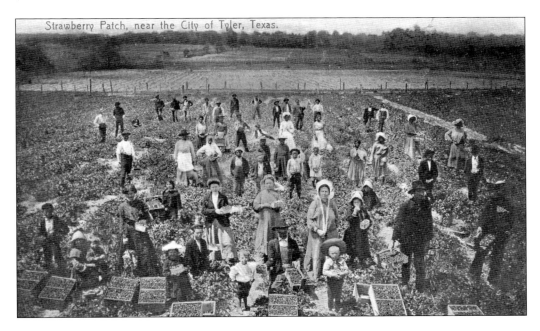

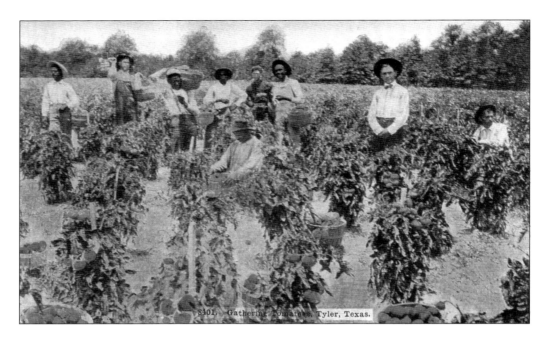

One of the vegetables that served as an important area truck crop was tomatoes, shown on these two postcards. Most tomatoes were grown in the communities just south of Tyler, and by 1908, the entire county crop yielded $126,800. Truck crops proved profitable not only for the farmers and the railroad, but also to local canneries and icehouses, many very close to the Cotton Belt Depot. John G. Woldert even made wine in his shop on the square with each of the aforementioned crops: peaches, strawberries, and tomatoes. In 1866 alone, he produced 300 gallons of wine. (Both, author's collection.)

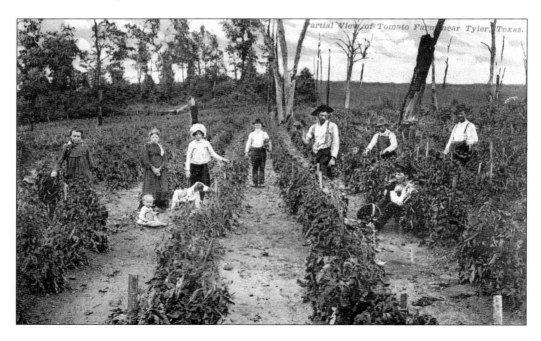

Tyler National Bank, located in the 100 block of West Ferguson Street, was founded in June 1892 by L. L. Jester. Name changes during the early years include Jester and Company in 1899; Jester National Bank in 1907; Jester Guaranty State Bank in 1911; Peoples Guaranty State Bank in 1914, when purchased by Sam Lindsey; Peoples State Bank in 1925; and finally Peoples National Bank in 1927. A new 15-story building was opened in November 1932 on the northwest corner of North College Avenue and West Erwin Street. It was the largest private building construction in the country west of the Mississippi River during the Great Depression. A 10-story addition on the back was added in 1936, visible on the postcard below. The bank, today a branch of Bank of America, moved into a new, adjoining 20-story building in 1980. (Both, author's collection.)

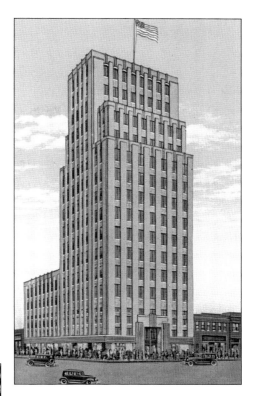

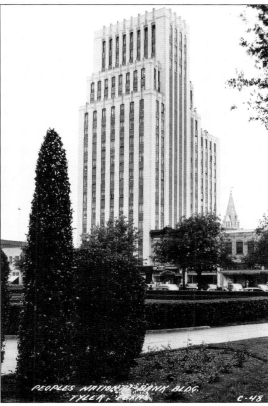

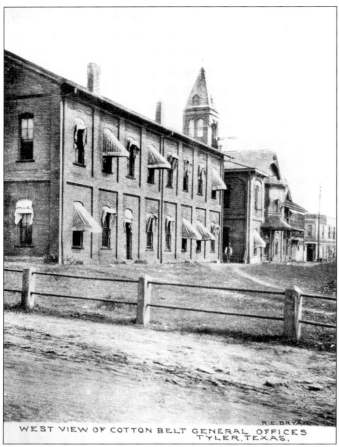

WEST VIEW OF COTTON BELT GENERAL OFFICES
TYLER, TEXAS.

This structure, built in 1880–1881 for use as the depot for the Tyler-based Kansas and Gulf Short Line Railroad, was located just east of North Palace Avenue, between West Ferguson Street and West Erwin Street. In 1891, the Tyler Southeastern Railway also housed its offices here. The Short Line became part of St. Louis and Southwestern Railway in 1899, and eventually the building was solely used for their general offices. By November 1902, the multistory section on the north end, shown in the foreground at left, was added. A two-story section that extended westward, shown jutting out to the right in the below view, was also added by September 1907. Both postcards are looking from the north at the west side of the building. (Left, courtesy Smith County Historical Society; below, author's collection.)

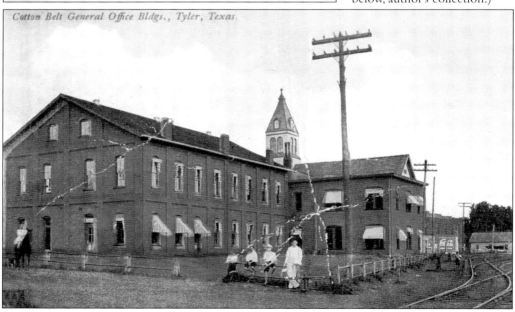

Cotton Belt General Office Bldgs., Tyler, Texas.

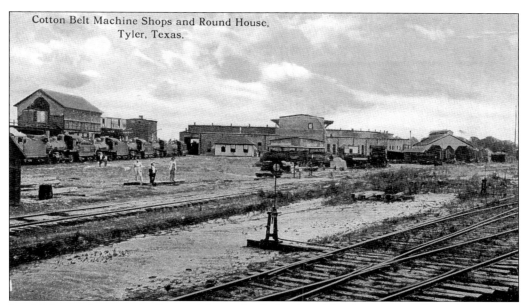

Cotton Belt Machine Shops and Round House, Tyler, Texas.

In addition to the general offices and depot, the St. Louis and Southwestern Railway also operated other facilities in Tyler. The first Cotton Belt Hospital was built here in 1888 and remained for 17 years. Other examples are the rail yards and shops, shown above, just east of the North Beckham Avenue overpass. The view includes the coal house and water tank to the left and the roundhouse in the center. (Author's collection.)

Mayer and Schmidt moved their department store to the northwest corner of North College Avenue and West Ferguson Street in 1893. The store, shown at right, was built on land made available when Alfred Ferguson's hotel burned. The new store was considered the area's most spacious and luxurious. In 1956, it became an early component of the Dillard's chain but operated under its original name at this location until 1974. (Author's collection.)

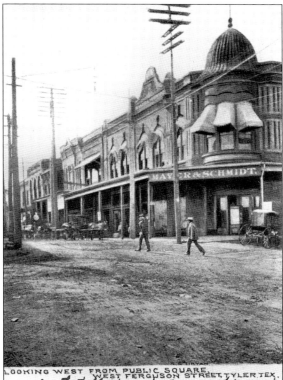

LOOKING WEST FROM PUBLIC SQUARE. WEST FERGUSON STREET, TYLER, TEX.

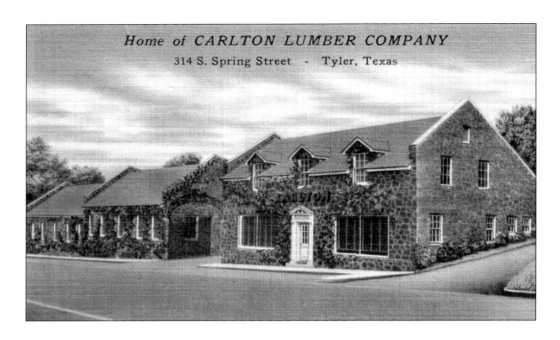

Home of *CARLTON LUMBER COMPANY*

314 S. Spring Street - Tyler, Texas

Carlton Lumber Company opened in 1895 and for many years was located at 100 East Line Street, where North Broadway Avenue originally narrowed just south of the railroad track crossing. Around 1940, it moved to 314 South Spring Avenue, shown above, where its sister company Carlton Mirror and Glass also operated. They closed around 1963. Smith County Lumber Company opened around 1947 at 213 North Fenton Avenue, shown below. There also was a location in nearby Lindale. The Tyler operation moved to 213 North Glenwood Boulevard around 1952, and it closed by 1974. (Both, author's collection.)

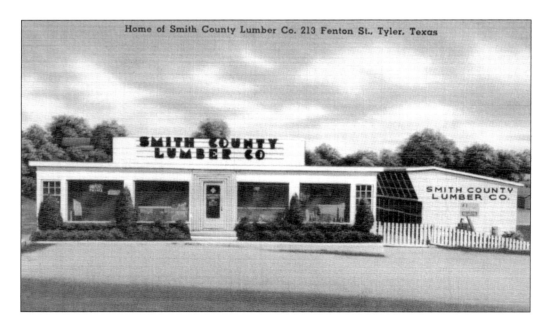

Home of Smith County Lumber Co. 213 Fenton St., Tyler, Texas

Palestine, Texas, investors supplied over $78,000 of the $100,000 starting capital of Citizens National Bank, which opened on June 2, 1900. Two other Tyler banks merged with Citizens in 1908, and it moved to the northeast corner of North Broadway Avenue and East Ferguson Street. That original two-story structure was demolished in 1924 and replaced with an eight-story building, seen on both of these postcards. In 1955, the name changed to Citizens First National Bank to reflect its standing as the oldest national bank in Tyler, and at the end of that year, it was the city's largest bank. An adjoining eight-story tower constructed in 1960 was demolished in 1978 to make way for construction of a new headquarters, and the original 1924 building was imploded in 1980. After several mergers, today it is Regions Bank. (Both, author's collection.)

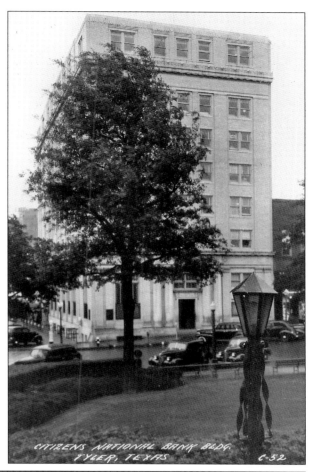

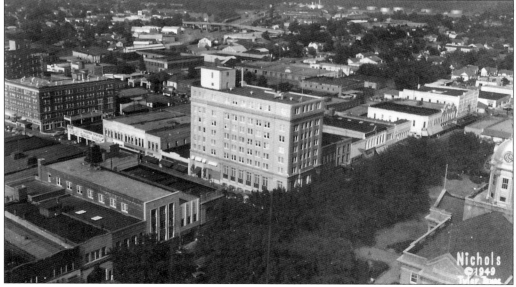

AN OLD SOUTHERN HOME
Tyler, Texas

By September 1898, the old Franklin N. Gary home, located at 225 North Bois D'Arc Avenue, was being operated as a boardinghouse. In 1918, Mattie Shields Clyde moved into the house and continued its use as a boardinghouse until she retired. The home was demolished in the late 1930s to make way for a parking lot for the adjoining gas station. (Courtesy Smith County Historical Society.)

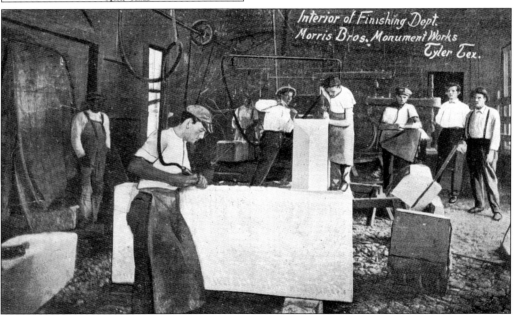

By 1907, Morris Brothers Monument Works, also called Marble Works or Granite Works, was in operation at 724 West Ferguson Street. The Morris brothers were Charles and James, and their location on the opposite side of the tracks from the St. Louis and Southwestern Railway general offices most likely allowed their stone to be delivered by rail to their doorstep. The business closed by the mid-1920s. (Courtesy Bill and Sue Corbin.)

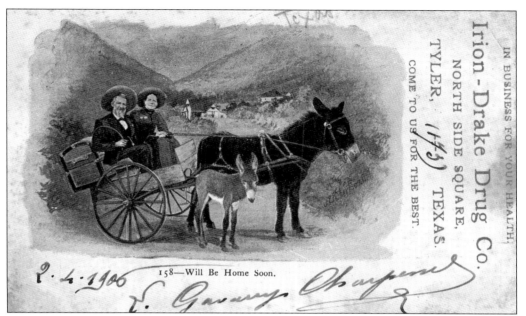

Irion-Drake Drug Co.
NORTH SIDE SQUARE,
TYLER, (1·3) TEXAS.
COME TO US FOR THE BEST.
IN BUSINESS FOR YOUR HEALTH.

158—Will Be Home Soon.

In 1904, Robert D. Irion was a pharmacist at Griffiths Drug Store. By 1906, he was a partner in Irion-Drake Drug Company, located at 107 West Ferguson Street and advertised on the above generic-image postcard. Robert was the sole proprietor of Irion Drug Company at the same location by 1913. The business moved to 237 South Broadway Avenue around 1942, and a second location opened at 101 East Eighth Street around 1958. The original location continued until around 1967, while the second shut down by 1973. Phillip Walsh Malloy operated Malloy Prescription Pharmacy at 106 South Broadway Avenue, shown at right, in the 1940s, moving around 1954 to 422 South Beckham Avenue. After closing his business, he was a manager at a Neil-Simpson Drug location for years. (Both, author's collection.)

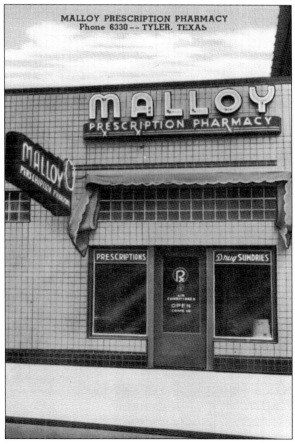

MALLOY PRESCRIPTION PHARMACY
Phone 6330 -- TYLER, TEXAS

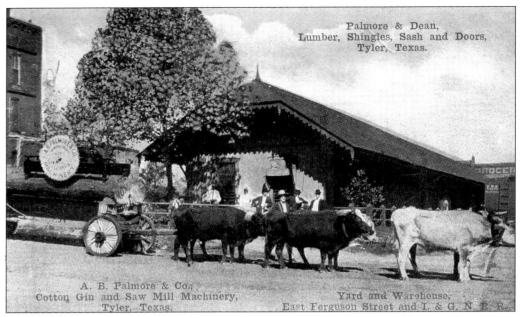

A. B. Palmore and Company, a machinery dealer, and Palmore and Dean, a building supply company, were both in operation by 1912 at 301 East Ferguson Street, in a building that was formerly a roller-skate rink. On the postcard, the International and Great Northern Railroad track is shown to the far right, with the freight depot appearing behind the oxen. The National Hotel appears in the far left background. (Author's collection.)

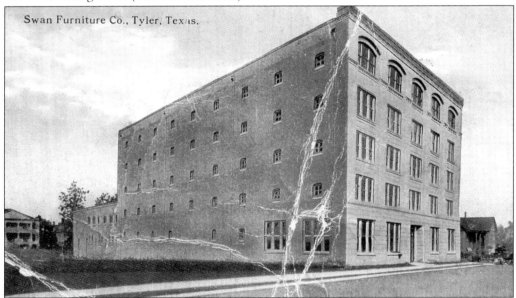

Alfred Ferguson sold his home to the Grinnan family in 1872, and Thomas E. Swann bought it from the Grinnan estate in 1911. Thomas replaced the home in 1913 with this five-story structure, located at 408 North Broadway Avenue, for his furniture and undertaking business. In 1917, Moore Grocery Company bought the building, as did Dennard Supply Company, a hotel and restaurant supplier, in 1956. Today it is loft housing. (Author's collection.)

Tyler Marble Works, advertised on the above postcard, was operated by Alva A. Wolcott and her son Joe. These monument dealers opened in the early 1920s at 421 North Spring Avenue but moved to 319 East Erwin Street around 1925. They closed soon afterward. By 1945, Vance Burks Memorials was in operation at 614 East Erwin Street. Around 1947, the business relocated to 108 South Fannin Avenue, shown below, immediately to the west of the International and Great Northern Railroad track. When Vance passed away, his wife, Virginia, continued the operation for a short while before selling it to Clyde Morris. By 1962, the business was closed. (Both, author's collection.)

Photo by John Dorris

Vance Burks Memorials, Tyler, Texas

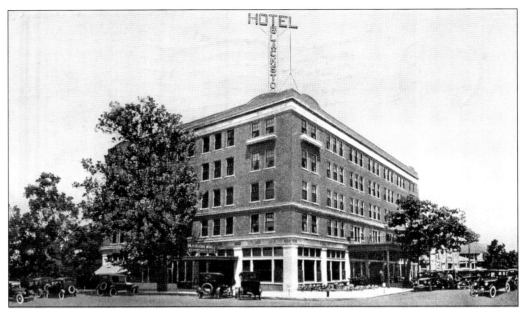

Construction began in October 1921 on the Blackstone Hotel, located on the northeast corner of North Broadway Avenue and East Locust Street. The above postcard shows the appearance the completed five-story hotel had when the grand opening occurred on November 29, 1922. An early advertisement called it "the pride of East Texas" and boasted that its restaurant provided "only the best food . . . served by experienced white waiters." The 1930s brought a nine-story addition on the north side, shown below, and air-conditioning. The most unusual guest brought the hotel nationwide publicity. He stayed on March 27, 1954, in the Governor's Suite, which had been "recarpeted" with hay and sawdust. The guest was named Prince 105 TT Aberdeen-Angus, a 1,760-pound bull that, just purchased for $230,000, was then the "highest-priced bull in the world" of its breed. (Both, author's collection.)

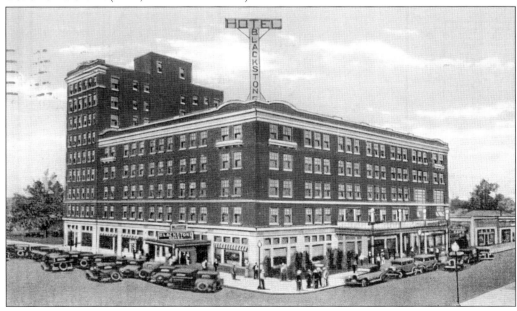

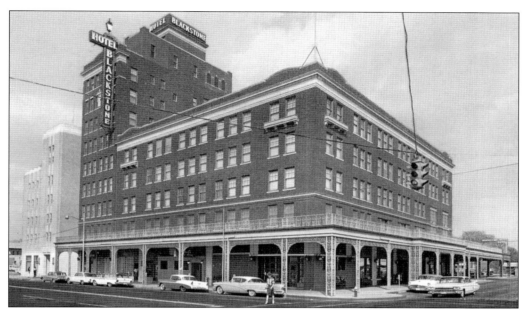

Blackstone Hotel renovations in the 1950s included a modernized interior and a 30-room east wing and parking garage addition. The postcard above shows the cast-iron portico added outside to give a New Orleans flavor, as well as the Blackstone Building, a freestanding office structure built to the north in 1939. The hotel closed on December 31, 1975, and was imploded in 1985. The Blackstone Building still remains today. (Author's collection.)

Grapette Bottling Company (above) was located at 1123 East Erwin Street. Soft drinks were bottled in Tyler since the early 20th century. Coca-Cola Bottling Company was located at 1522 West Erwin Street. Coca-Cola was earlier handled by Riviere Bottling Company at 1609 North Bois D'Arc Avenue, but it dropped that brand to bottle Dr. Pepper and 7-Up. Other major and lesser known sodas were also bottled in the city. (Author's collection.)

Home of LEWS WELDING SERVICE—MACHINE SHOP—RADIATOR SERVICE—Tyler, Texas

Lewis S. Forman began his welding career in 1928. By 1936, he operated Lew's Garage at 1716 East Erwin Street, the same location where this business is today. In 1938, the name changed to Lew's Welding Service, although he actually listed two additional businesses at this address: Lew's Radiator Service and Lew's Machine Shop. (Courtesy of Smith County Historical Society.)

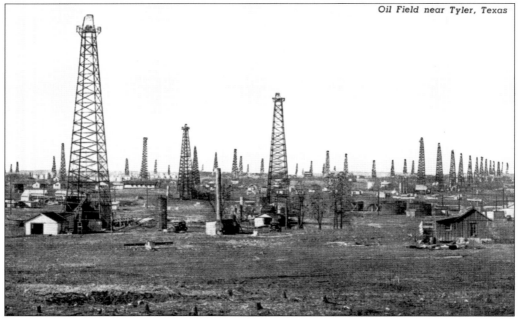

The discovery of the East Texas Oil Field, then the largest known in the world, helped Tyler survive the Great Depression easier than the rest of the country. After a 1930 successful well less than 30 miles from Tyler, the city's population appears to have doubled by 1935, occupying available living and office space. Construction boomed, from hotel expansions to new office buildings and residences. Restaurants and retail stores also benefited. (Author's collection.)

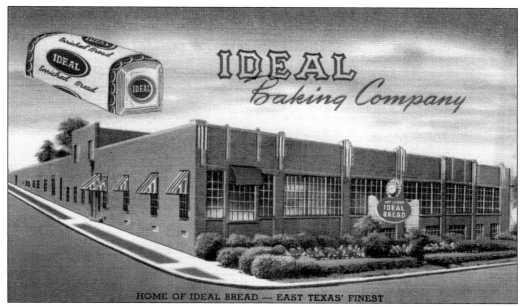

HOME OF IDEAL BREAD — EAST TEXAS' FINEST

Ideal Baking Company opened in the early 1930s at 501 East Erwin Street. Around 1934, the operation moved to 825 West Elm Street and then to 1200 West Erwin Street, shown above, around 1940. It sold bakery goods under the labels of both Ideal and Sunbeam. The company was sold to Harold Hyde and family in 1972, which in turn sold all their plants to Flowers Industries in 1981. (Author's collection.)

SCENE IN PRATT'S—EAST TEXAS LARGEST JEWELERS—TYLER

Pratt Jewelry Company was opened by George H. Pratt around 1932 on the north side of the downtown square at 115 West Ferguson Street. It called itself "East Texas Largest Jewelers," offering three floors of jewelry, silver, china, and a gift department, with free gift wrapping. The business closed around 1958. (Author's collection.)

The main factors in the rose industry's growth in Tyler are the slightly acidic, sandy soil and the climate, specifically the long growing season with good average rainfall. The earliest rose growers raised them alongside their other crops. Matthew Shamburger sold rosebushes as early as 1879, and his grandson Bonnie Shamburger exported the first rosebushes from Tyler by train in 1917, sending them to Ottawa, Kansas. When local peach growers lost their orchards to a major peach blight in the early 1900s, many of them turned to roses. The industry expanded rapidly in the 1920s, and soon the annual Texas Rose Festival brought more attention to Tyler's newest cash crop. It is estimated that at the peak, one-third to one-half of United States–produced rosebushes came from the Tyler area. (Both, author's collection.)

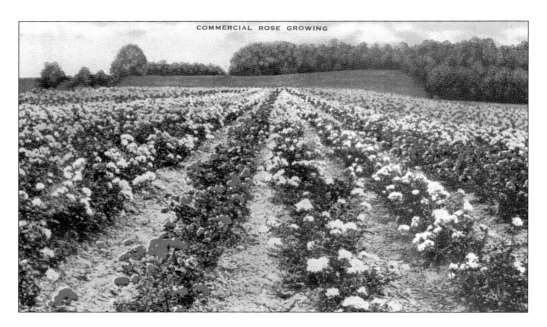

GET ACQUAINTED OFFER
all six for $3.00

Both of these *c.* 1930s postcards are for rose nurseries. The view at right is for Empire Nurseries, picturing six rose blooms below the statement "Get Acquainted Offer . . . all six for $3.00." The text on the back elaborates that the offer is for six different-colored, two-year-old, field-grown rosebushes and promises "armloads of cut roses." The below view picturing a large field of rosebushes is for Lang Rose Nurseries, which was located at 508 North Fannin Avenue. Mailed to Missouri in 1939, the postcard's back states that Lang has "500,000 roses in nearly 100 varieties," all two years old and priced reasonably, and encourages the reader to write for more information. A few prices can be seen hand stamped on the front side of the postcard. (Both, author's collection.)

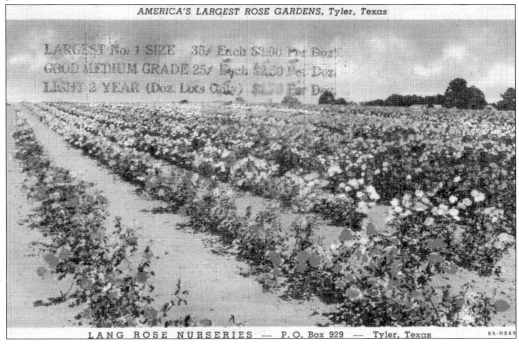

AMERICA'S LARGEST ROSE GARDENS, Tyler, Texas

LARGEST No. 1 SIZE 35¢ Each $3.00 Per Doz.
GOOD MEDIUM GRADE 25¢ Each $2.50 Per Doz.
LIGHT 2 YEAR (Doz. Lots Only) $1.50 Per Doz.

LANG ROSE NURSERIES — P. O. Box 929 — Tyler, Texas
6A-H949

Alamo Plaza Hotel Courts, located at 1800 West Erwin Street, opened around 1932 as part of a small chain located throughout the South. The interior-room view shown on the postcard was most likely not taken at the Tyler location. Some of the army staff attending the Signal Corps school in Tyler from April 1942 to July 1943 were housed here. The business became American Inn around 1999. (Author's collection.)

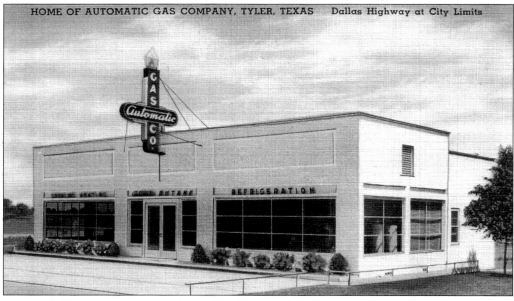

HOME OF AUTOMATIC GAS COMPANY, TYLER, TEXAS Dallas Highway at City Limits

Automatic Gas Company started in 1932 by Herbert C. Pittman and in the early days was located at 719½ North Bois D'Arc Avenue. By 1938, it had relocated to 2703 West Erwin Street, shown above, where it still operates. Over the years, the business sold butane and propane, as well as related appliances and heaters. From around 1954 to 1999, H. C. Pittman Furniture also operated at this same address. (Author's collection.)

Tyler Lumber Company opened around 1932 at 817 East Erwin Street but soon moved to 829 West Ferguson Street. Shown on the card at right postmarked 1950 are some of the display rooms. They offered lumber, hardware, paints, and wallpapers. Also they were "the only lumber company in Tyler that gives S&H Green Stamps." The business closed around 1955. (Author's collection.)

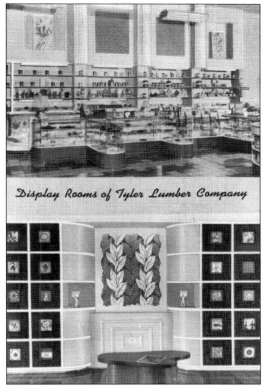

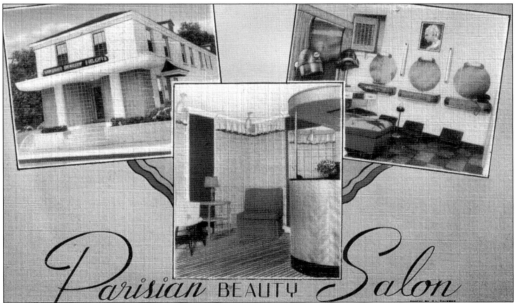

The Parisian Beauty Salon, originally a joint venture of Lillie Belcher, Chloe Kennedy, and Virginia Terry, opened about 1933 at 307 North Bois D'Arc Avenue. The operation, which advertised as "Texas' most distinctive salon of beauty," would later move to 116 West Fifth Street, shown on the postcard. It closed around 1960. (Author's collection.)

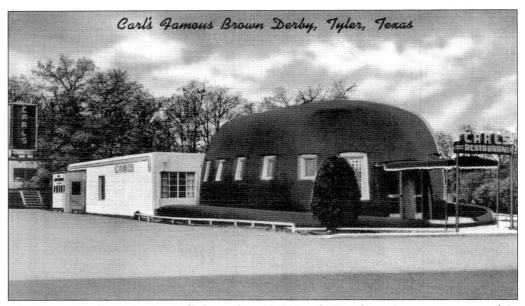

Carl's Famous Brown Derby, Tyler, Texas

The Brown Derby Drive-In Café, located at 1905 South Broadway Avenue, was opened in December 1935. The entire restaurant was originally enclosed in the hat-shaped structure, but in 1936, the kitchen was moved into a new building in the rear, and the entire "hat" was made a dining room. The restaurant closed in early 1953 and became a used car lot by 1956. The buildings were demolished in 1958. (Author's collection.)

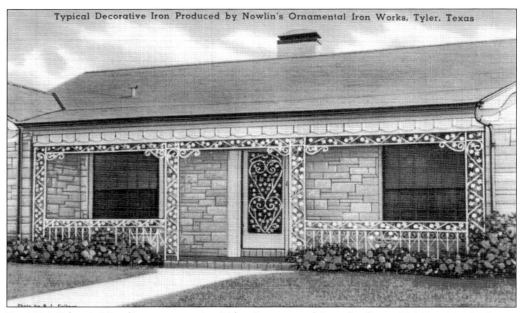

Typical Decorative Iron Produced by Nowlin's Ornamental Iron Works, Tyler. Texas

By 1936, John A. Nowlin was operating Tyler Ornamental Iron Studio at 821 East Erwin Street. He soon passed away, but his widow, Clestia, continued the business into the 1950s, with the name changing to Nowlin's Ornamental Iron Works sometime in the later 1940s. The business is still in operation today at 3401 East Fifth Street. (Author's collection.)

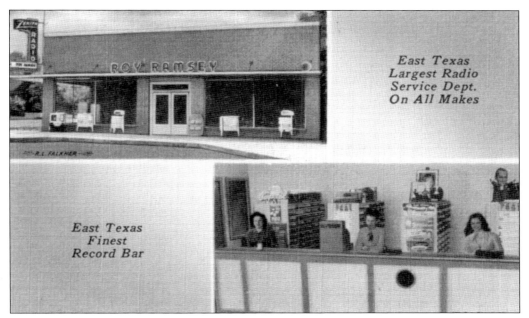

East Texas
Largest Radio
Service Dept.
On All Makes

East Texas
Finest
Record Bar

In 1933, Roy Ramsey worked as a service manager at D. R. Bryan Majestic Radio Shop at 111 University Place. By 1936, Roy opened his own business, Roy Ramsey Radio Shop, at 106 East Front Street. Around 1949, it had relocated to 121 East Front Street, shown above, and also offered records, refrigerators, and washing machines. Television service was added later. The business closed around 1964. (Author's collection.)

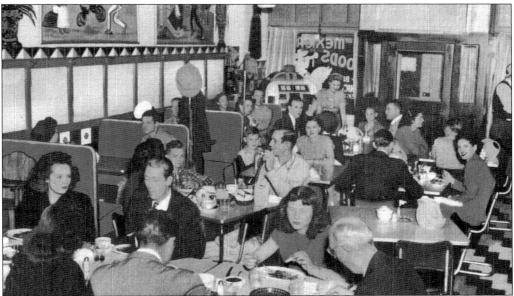

El Charro Mexican Café was opened at 1433 East Erwin Street around 1937. Gilberto Rameriz, an immigrant from Mexico in the early 1920s, became sole owner of the business in 1943. The restaurant moved to a new location at 2604 East Erwin Street, when El Charro No. 1 was built in 1952. A second location, El Charro No. 2, was built in 1962 at 2623 East Fifth Street and rebuilt after a 1997 fire. (Author's collection.)

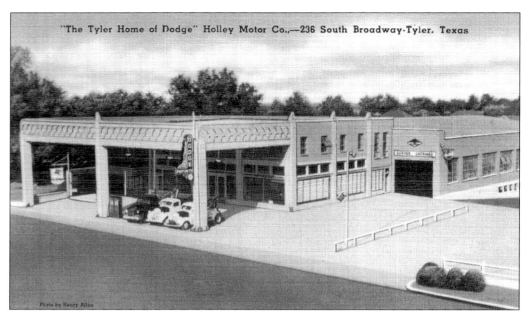

"The Tyler Home of Dodge" Holley Motor Co.,—236 South Broadway-Tyler, Texas

Photo by Henry Allen

By 1937, Claude S. Holley owned a service station, a taxi company, a radio service, and a car dealership. Holley Motor Company, shown above, was located at 236 South Broadway Avenue. It offered Dodge and Plymouth cars, Dodge trucks, and complete body and mechanical repair service. In 1958, the dealership also started carrying Chryslers and opened two used car lots. Claude turned the reins over to James S. Holley in 1962. The dealership is now long gone, and the building has housed several other business over the years. John Young started Young Motor Company on North Broadway Avenue around 1938. It offered Lincoln, Mercury, and Ford sales and service initially and moved to 800 West Erwin Street, shown below, around 1954. The business closed by 1967. (Both, author's collection.)

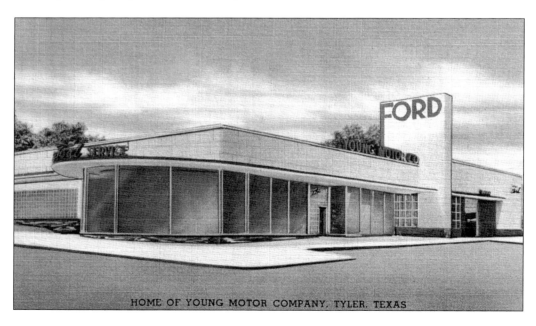

HOME OF YOUNG MOTOR COMPANY, TYLER, TEXAS

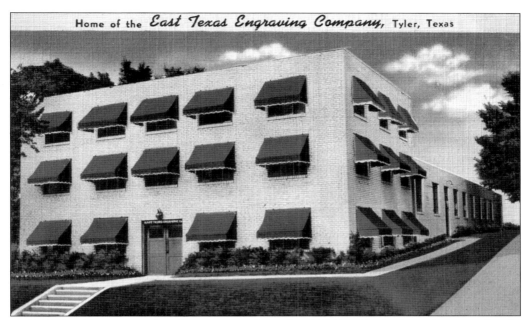

Home of the *East Texas Engraving Company*, Tyler, Texas

In 1938, East Texas Engraving Company was located at 322 East Erwin Street but moved to its current location of 116 South Beckham Avenue by 1947. This was also the home of Nationwide Advertising Specialty Company, and together they produced advertising calendars, novelties, and postcards, including this one and many others in this book. They once claimed to be America's largest mail-order engravers. (Author's collection.)

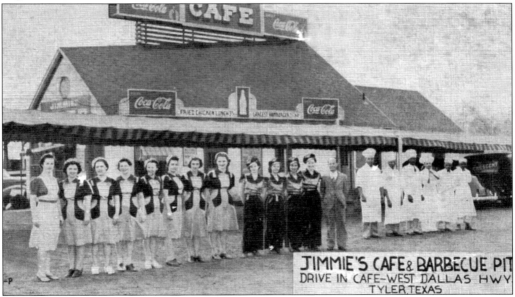

Jimmie's Café and Barbecue Pit opened in November 1938 on the northeast corner of West Erwin Street and North Hill Avenue. Owned by James and Peggy Prickett, it also offered carhop service. The Pricketts sold the business in 1944, but it operated under the same name into the 1950s. An early menu states the restaurant was open 24 hours and includes calf's brains and scrambled eggs for 35¢. (Author's collection.)

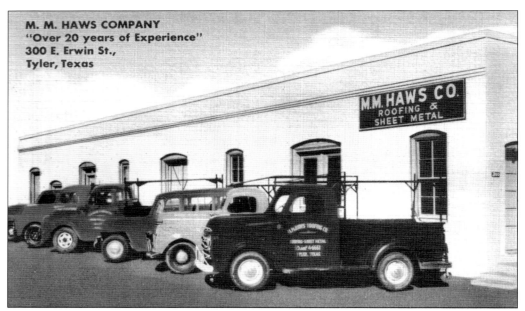

Max M. Haws opened M. M. Haws Company in 1933, offering sheet metal and roofing work at his downtown South Spring Avenue location. After later partnering with J. G. Gwin for a few years, the business moved to 109 Swan Street in 1940, then to 300 East Erwin Street, shown above, in 1942. The name changed to Haws Roofing Company in the mid–1950s. Still family owned and operated, the business moved to Rhones Quarter Road in 1987. (Author's collection.)

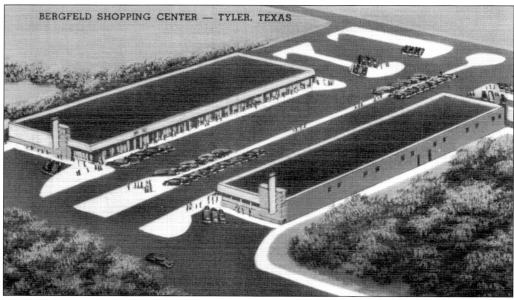

Bergfeld Center was the first shopping center in East Texas and the second in all of Texas. Developed in the late 1940s by Julius A. Bergfeld and his son Julius L. Bergfeld Sr., the original layout, shown above, was bound by South Broadway Avenue on the west and Roseland Boulevard on the east and bisected by East Eighth Street. Village Bakery, opened in 1948, is the last of the original stores. (Author's collection.)

In 1947, John W. Gilley was working for East Texas Awning and Machinery Company, located at 1303 West Erwin Street. By 1949, he had his own business, J. W. Gilley Awning Company, located on Troup Highway, but it would move to 111 South Glenwood Boulevard about a year later. The business continued until 1953, when it became Capco Awning Company. The postcard advertises the awnings placed on the East Texas Engraving Company. (Author's collection.)

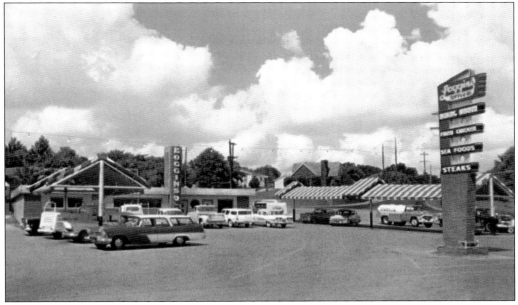

Loggins Drive-In, located at 137 South Glenwood Boulevard, was opened in February 1949 by brothers Paul and J. C. Loggins, but Paul eventually became sole owner. It was originally a drive-in with carhops and a very small dining room. In 1959, the drive-in aspect was discontinued, the interior dining area was enlarged, and the name changed to Loggins Restaurant. When Paul passed away in 1985, his son Jerry took over the business. (Author's collection.)

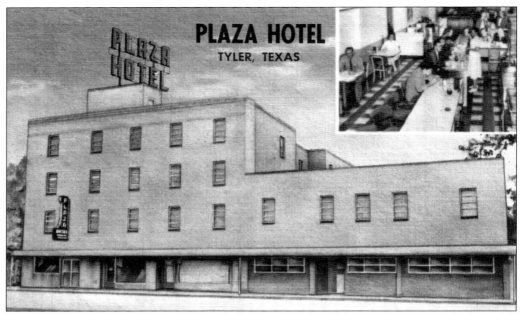

Around 1949, Plaza Hotel opened at 515 East Erwin Street. Located just three blocks from the square, the hotel offered a coffee shop, shown above in the upper right corner, and 100 air-conditioned rooms, each with a television and private bath. After the hotel closed in 1975, it became the Tysen House, a senior citizen residence, which closed around 1998. The building remains empty today. (Author's collection.)

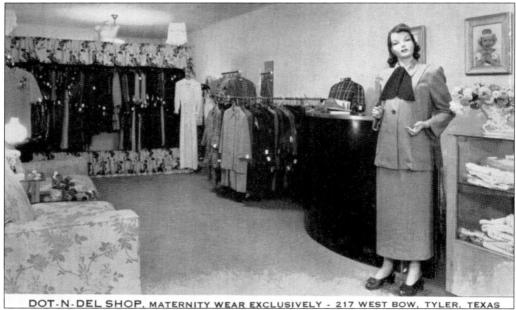

Dot-n-Del Shop opened around 1949, taking its name from owners Dorothy Allen and Adele Prater. Originally located at 217 West Bow Street, shown above, the business moved to 106 East Front Street around 1952. The store advertised itself as "Tyler's finest exclusive maternity shop." It closed around 1975. (Author's collection.)

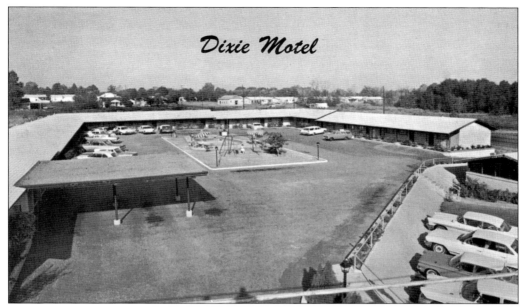

Dixie Motel opened around 1950 at 1812 East Gentry Parkway. The motel featured a swimming pool and restaurant, as well as 28 air-conditioned rooms with free coffee, telephones, and five channels of television. Around 2001, the name changed to Relax Inn, and the motel remains open today. (Author's collection.)

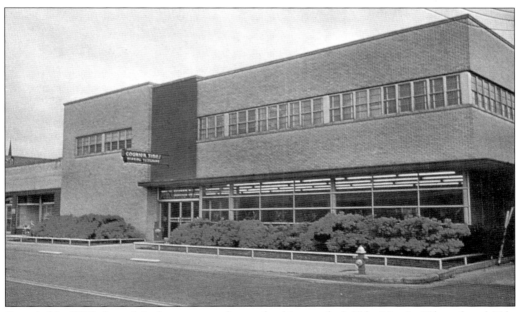

Founded in 1877, the original newspaper that evolved into today's *Tyler Morning Telegraph* and *Tyler Courier-Times-Telegraph* had fallen into hard times after suffering major losses in a fire, and it was purchased by Thomas B. Butler in November 1910. Thomas died less than a decade later, but T. B. Butler Publishing Company, shown above at 410 West Erwin Street, remains today a family-owned and operated business. (Courtesy Calvin Clyde Jr.)

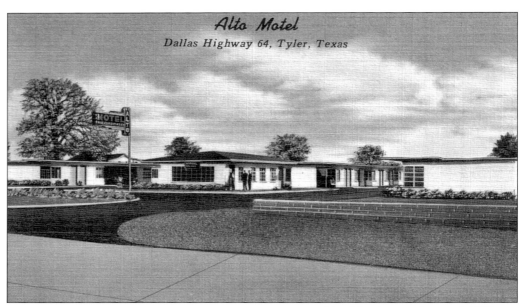

Alto Motel

Dallas Highway 64, Tyler, Texas

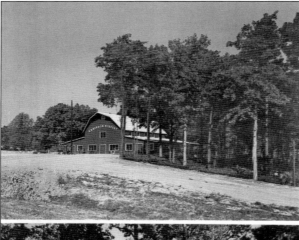

Alto Motel opened around 1952 on State Highway 64, four miles west of downtown, near the airport. It advertised as having "the latest high class accommodations—28 units—all refrigerated air conditioned, steam heated, private telephones, running ice water in each unit." There also was a garage for each unit. The motel changed its name to Maria Motel in 1956 and closed in 1964. (Author's collection.)

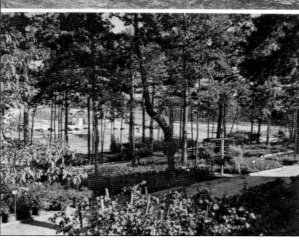

Elbert Barron opened the E. B. Barron Nursery around 1954 on Highway 31, about 2 miles west of downtown Tyler. He sold wholesale and retail, with trees and roses a specialty and immediate delivery on stock. The office and sales room was located along the highway, with the garden and tree stock in the rear. The business closed around 1993. (Author's collection.)

KLTV began broadcasting on October 15, 1954, sharing programming time with ABC, CBS, and NBC. In the early 1980s, it became strictly an ABC affiliate. The station was founded by Lucille Buford, reportedly the first woman to own and operate a television station. It was originally located on East Loop 323 in a former hanger of the old Stewart Field airport. KLTV moved to 105 West Ferguson Street in 1996. (Author's collection.)

The Carlton Hotel, located on the northeast corner of South Broadway Avenue and West Elm Street, opened in November 1954. In addition to 200 rooms, the hotel featured a coffee shop, a banquet hall, and a parking garage. Atop the three-story garage was a swimming pool, shown above. It closed in November 1971, forcing out 30 permanent residents. Smith County bought the building for use in 1977. (Author's collection.)

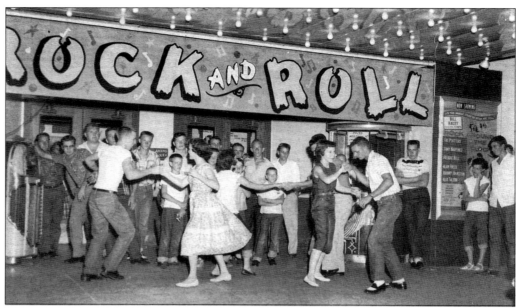

This *c.* 1956 postcard shows a "Rock and Roll" promotion, complete with jukebox and dancers, in front of the Arcadia Theater at 123 North Spring Avenue. The advertised movie is *Rock Around the Clock*, and the sign in the box office window states that adult tickets are 40¢. The Arcadia Theater, opened in 1925 and closed in 1988, was the first theater in Tyler to show "talkies." (Author's collection.)

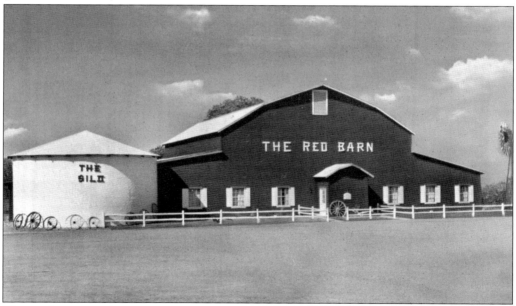

The Red Barn Steak House opened around the mid-1960s. Located at 6611 South Broadway Avenue, the restaurant, when new, was located south of the city limits, literally out in the country. It featured charcoal-broiled steaks and boasted banquet facilities for up to 500. The business closed around 1984. Today the structure houses a child care facility, well within the city limits. (Author's collection.)

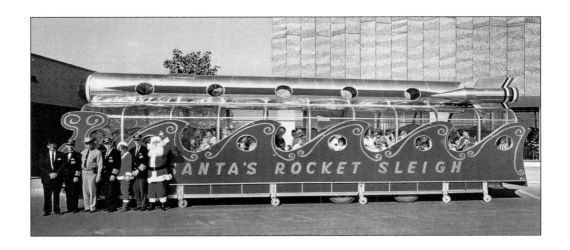

The Santa Claus Rocket Corporation formed around 1974. With Lloyd B. Laster as president, the company operated these custom-built, space-age-style vehicles, making scheduled, seasonal visits to give children free rides with Santa, his space hostess, pilot, and copilot. The vehicle shown above was named "Santa's Rocket Sleigh" and seated 120 children, while the vehicle shown below was named "Santa's Rocket Ship" and seated 65 children. A third vehicle named "Santa's Space Sleigh" is barely visible in the background of the below view, but a photograph of it appears in this author's book Images of America: *Tyler*. The business closed when Lloyd retired around 1978. (Both, author's collection.)

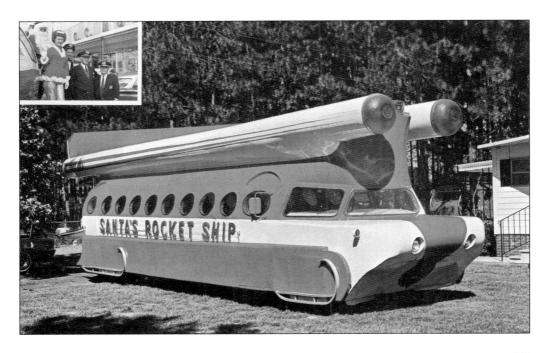

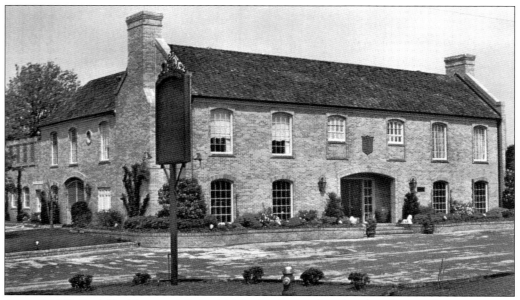

Around 1960, Paul Grubb started Colonial Metalcrafters, a shop hand-making 18th-century-style brass, such as chandeliers and lanterns. His son Paul Jr. took over the operation in 1962. In 1974, it became part of a new larger venture of the son: Brass Lion Antiques. Shown above, this business was located at 5935 South Broadway Avenue until it closed around 2006. (Author's collection.)

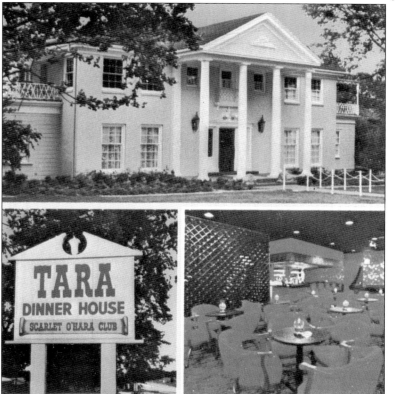

Originally a residence built in 1939, Tara Dinner House was opened in May 1976 by Sam and Ruth Black. Located at 3380 Mineola Highway, the restaurant seated 260, featured steaks and seafood, and included the Scarlett O'Hara Club, whose name kept with the "Gone with the Wind" theme. It closed in the early 1980s, and the building went through a series of uses. Today it houses a church. (Author's collection.)

Nine

RECREATION AND ORGANIZATIONS

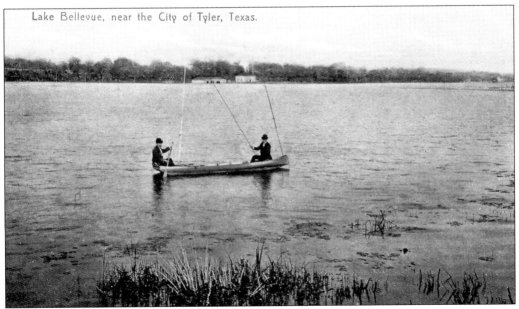

Lake Bellevue, near the City of Tyler, Texas.

The 170-acre Bellwood Lake, mislabeled on this postcard as Lake Bellevue, was created in 1894 by a dam built across Indian Creek to the west of town. The dam was created by a hydraulic fill process, which later placed it on the National Register of Historic Places. Tyler purchased a private water treatment plant on the lake in 1916, which supplied the city water until it was retired in 1965. (Author's collection.)

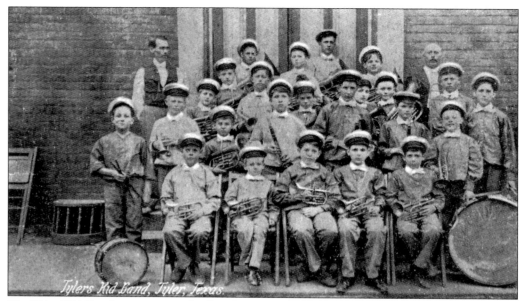

The Tyler Kid Band was composed of local youth, formed around the dawn of the 20th century. The postcard above was mailed in 1908, the same year "Doc" Witt became their bandmaster. The group was later renamed Tyler Municipal Band and performed free weekly concerts on the public square. Doc later organized the bands for Tyler High School in 1921 and Tyler Junior College in 1947. (Courtesy Smith County Historical Society.)

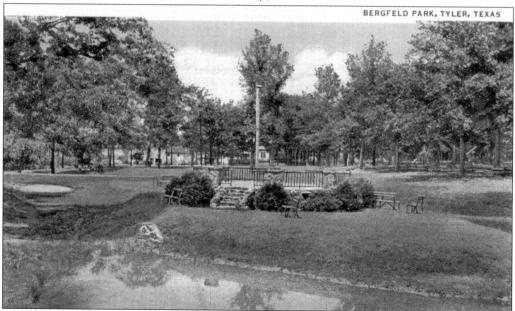

Rudolph Bergfeld donated land to the city in 1909, stipulating that it be used for a public park. In 1913, it was developed and named Bergfeld Park, and many early Rose Festival events took place there. The small lake shown was replaced by an amphitheater in 1936, donated by the Sears, Roebuck, and Company because only their Tyler store made a profit during the Great Depression. (Author's collection.)

On July 1, 1909, this monument, provided by the Mollie Moore Davis Chapter of the United Daughters of the Confederacy, was dedicated in Oakwood Cemetery, located on the southeast corner of North Palace Avenue and West Oakwood Street. Confederate veterans were honored guests at a picnic on the east side of the courthouse. A parade headed to the cemetery at 2:00 p.m., where an estimated 5,000 people gathered for the event. (Author's collection.)

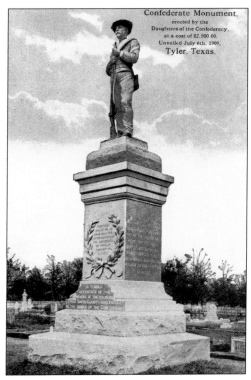

A group of 63 citizens met in April 1921 to organize what would become Willow Brook Country Club. Located at 3205 West Erwin Street, the original frame clubhouse, shown above, opened in June 1923, along with a nine-hole golf course. A swimming pool was added in 1935, and a second nine holes of golf were completed in 1946. The current clubhouse opened in October 1962 east of the original. (Author's collection.)

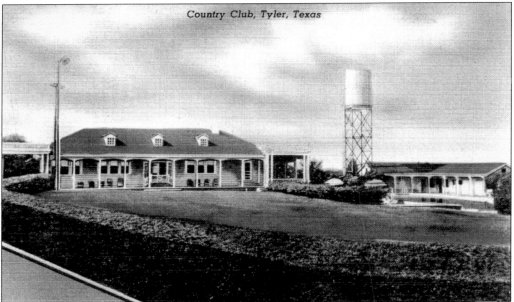

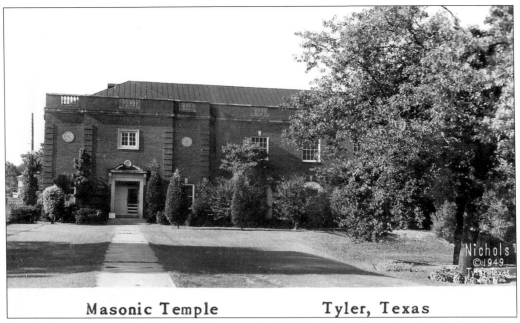

Masonic Temple Tyler, Texas

St. John's Masonic Lodge No. 53 is shown at its 323 West Front Street location, built in 1923. Their 1849 charter was arrested in 1925 for 10 months because of "turmoil," reportedly from new petitioners being required to also petition for Ku Klux Klan membership. Tyler Lodge No. 1233 was chartered during this time by former St. John's members. Once the KKK requirement was dropped, St. John's charter was restored. (Author's collection.)

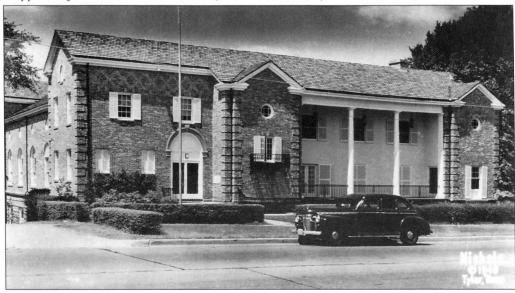

Several literary clubs merged in 1923 to form the Woman's Forum, whose major purposes are educational and civic programs. Judge Samuel Lindsey donated land in 1931 for the group's building site, if the construction was completed within one year. With community support, the building, shown above, was completed in June 1932. The building has party rooms, a kitchen, and an auditorium and once had apartments on the top floor. (Author's collection.)

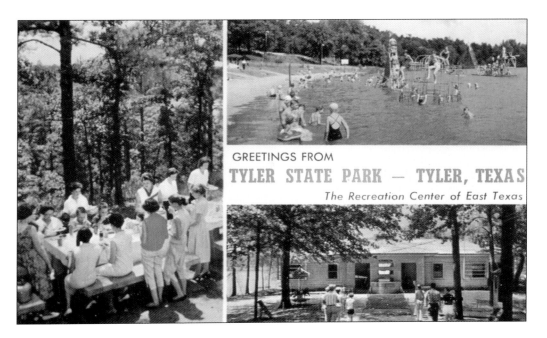

GREETINGS FROM

TYLER STATE PARK — TYLER, TEXAS

The Recreation Center of East Texas

Tyler State Park, located north of the city on Farm-to-Market Road 16, opened in 1939. Private landowners deeded over 985 acres in the mid-1930s for use as the park. The original improvements were made by the Civilian Conservation Corps, a New Deal program. Much of the stonework seen today throughout the park was built by the CCC workers. An earthen dam created a spring-fed, 64-acre lake. During World War II, soldiers training at nearby Camp Fannin were frequent visitors of the park. The dam broke in September 1963, and the lake drained, but it was rebuilt. Today activities include swimming, fishing, hiking, camping, canoeing, and biking, but in the past they also included miniature golf and dances. (Both, author's collection.)

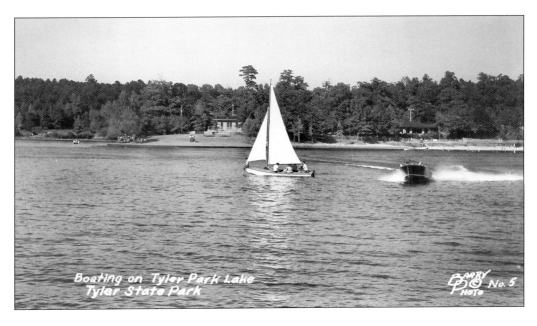

Boating on Tyler Park Lake
Tyler State Park

M. W. (Tiny & Nita) CHAMBLESS

W 5 PAR

TNX FOR. QSO

820 W. Glenwood
TYLER, TEXAS

Rose Capital of the World

Martin W. Chambless and his wife, Juanita, had these postcards printed, obviously showing that they were ham radio enthusiasts. They moved to Tyler by 1945, living at 820 West Glenwood Boulevard. He was working as the assistant manager at McCullough Tool, an oil well service company, when they moved away around 1951. QSL postcards, such as this one, are used by amateur radio operators to provide written confirmation of two-way radio reception between stations. (Author's collection.)

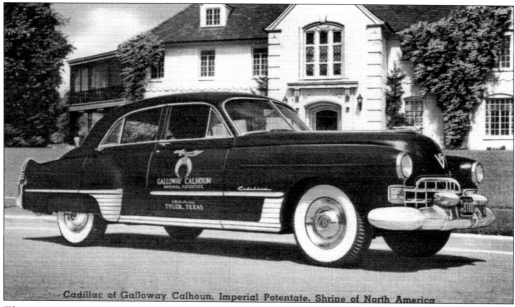

Cadillac of Galloway Calhoun, Imperial Potentate, Shrine of North America

The caption on this postcard's reverse side tells the complete story: "This beautiful Cadillac 62 Sedan was purchased from Talley Cadillac Company of Tyler, Texas, by the 10 Shrine Temples of Texas, and presented to Galloway Calhoun, Tyler attorney, at Atlantic City on the occasion of his election as Imperial Potentate of the Ancient Arabic Order of the Nobles of the Mystic Shrine for North America, 1948–49." (Author's collection.)

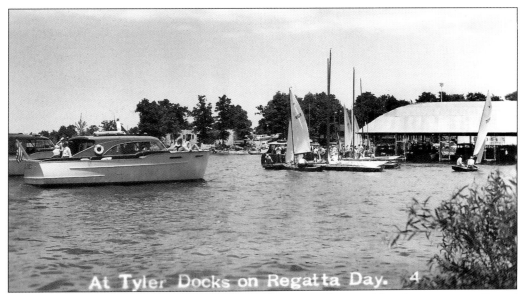

The dam on Lake Tyler was completed in January 1949. Fishing and boating were not allowed until June 1950, when the lake was officially full, and it began use as a city water supply soon after. The dam on Lake Tyler East, the larger of the pair, was completed in January 1967. After the new lake filled, a connecting channel between both was opened in April 1969. (Author's collection.)

Tyler KOA Kampground opened in 1969 at the Harvey Road exit on Interstate Highway 20. In addition to the campgrounds, it featured a grocery store, Laundromat, and swimming pool. Its name changed to Tyler 554 Campground around 1989, with the 554 referring to the exit number for Harvey Road. Around 1997, the name changed to its current name of Yellow Rose RV Resort. (Author's collection.)

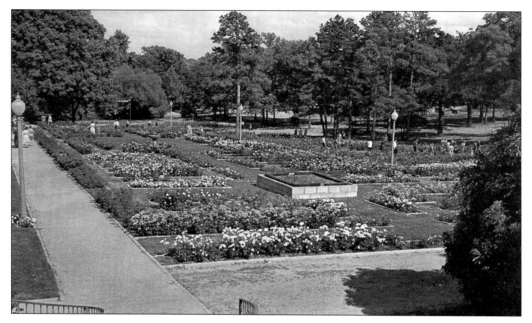

Tyler's rose industry was well known, and while the Texas Rose Festival had been an annual event for almost two decades, there was no city park that showcased the rose. That was about to change in the early 1950s. To the immediate east of the East Texas Fairgrounds was a patch of eroded land that was little more than an eyesore. Robert Sullivan, city director of public services, saw the land's potential, and he enlisted Dr. Eldon W. Lyle of the Texas Rose Research Foundation to evaluate the plot. Eldon's verdict was that roses would require help to grow there. The city spent $5,000 for soil improvement and landscaping, and Tyler-area rose growers donated thousands of bushes. A municipal rose garden became a reality when it was dedicated in June 1952. (Both, author's collection.)

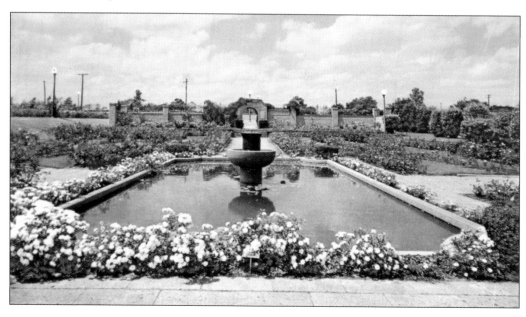

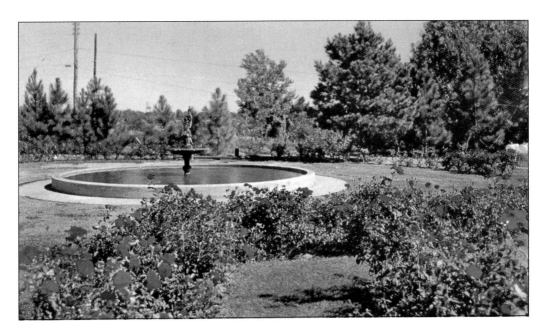

Thousands more bushes were added to the rose garden over the years, as well as walkways and fountains. The Rose Garden Center was built in 1953 as an entrance to what became recognized as the nation's largest municipal rose garden. The Queen's Tea, a Texas Rose Festival event that was originally held at the home of the queen's parents, moved to the large lawn in the rose garden in 1956. As space needs and maintenance costs increased, a larger building replaced the original in 1992, costing $2.2 million. The new center also houses the Tyler Rose Museum, dedicated to preserving the city's rose heritage, as well as a gift shop, meeting rooms, and more. Today more than 100,000 visitors come through this rose showplace each year. (Both, author's collection.)

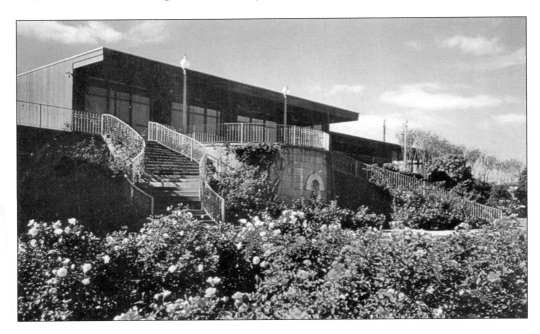

www.arcadiapublishing.com

Discover books about the town where you grew up, the cities where your friends and families live, the town where your parents met, or even that retirement spot you've been dreaming about. Our Web site provides history lovers with exclusive deals, advanced notification about new titles, e-mail alerts of author events, and much more.

MADE IN THE USA

Arcadia Publishing, the leading local history publisher in the United States, is committed to making history accessible and meaningful through publishing books that celebrate and preserve the heritage of America's people and places. Consistent with our mission to preserve history on a local level, this book was printed in South Carolina on American-made paper and manufactured entirely in the United States.

This book carries the accredited Forest Stewardship Council (FSC) label and is printed on 100 percent FSC-certified paper. Products carrying the FSC label are independently certified to assure consumers that they come from forests that are managed to meet the social, economic, and ecological needs of present and future generations.

FSC
Mixed Sources
Product group from well-managed forests and other controlled sources

Cert no. SW-COC-001530
www.fsc.org
© 1996 Forest Stewardship Council

Find Your Place in History.